FLORIDA
Sweets

FLORIDA
Sweets
KEY LIME PIE, KUMQUAT CAKE & CITRUS CANDY

JOY SHEFFIELD HARRIS

AMERICAN PALATE

Published by American Palate
A Division of The History Press
Charleston, SC
www.historypress.net

Front and back cover, historic postcards courtesy of the State Library and Archives of Florida.
All black-and-white photographs courtesy of the Florida Memory Archives unless otherwise
noted. All color photographs belong to the author unless otherwise noted.
"Flamingo Pink Lime Pie," from *Easy Breezy Florida Cooking* by Joy Harris and Jack Harris.
Published by Seaside Publishing, an imprint of the University Press of Florida, 2008.
Reprinted with permission.

First published 2017

Manufactured in the United States

ISBN 9781467137652

Library of Congress Control Number: 2017934939

Notice: The information in this book is true and complete to the best of our knowledge. It is
offered without guarantee on the part of the author or The History Press. The author and
The History Press disclaim all liability in connection with the use of this book.

Dedicated to my mother and in memory of my father.

Our mother, Mary Frances Sheffield, and my brother, Patrick Sheffield, and I established a scholarship fund at Tom P. Haney Technical Center in Bay County in honor of our father, Master Sergeant Floyd Sheffield. A portion of the proceeds from this book will go to that scholarship. When my father was in the VA nursing home, Pat would visit him every day, and Daddy would tell stories of life growing up in North Florida during the Great Depression. He wasn't eating much, so Pat's wife, Carolyn, a nurse, told him he is "old enough to eat his dessert first." So Pat fed him dessert and listened to his stories of growing up among the pines and palms of North Florida. Here is his story, as told by Pat.

Floyd, one of seven children, was raised in the backwoods sandhills of northwest Florida. A fifth-generation Floridian, born in Bonifay just prior to the Great Depression in 1925, his childhood years fell on hard times. In the late 1930s, Floyd's father was being sought by the local sheriff for bootlegging whiskey. Rather than face jail time, he deserted the family and left them to fend for themselves. This was prior to government programs such as welfare, food stamps and unemployment benefits. Granny (Mattie Lenora) Sheffield was unable to work due to lack of skills and the burden of caring for a large family. Consequently, Floyd dropped out of school after ninth grade to work and provide for his mother and sisters. In 1939, at fourteen years old, he became the family

breadwinner, feeling the full weight of the Great Depression, which was particularly devastating to North Florida.

As an unskilled country boy, the only work he found were low-paying jobs in Panama City, but with the outbreak of World War II, there was a shortage of male workers. After several years and failed attempts to pass the entrance physical examination due to an existing shoulder condition, the military lowered the physical standards for entry, allowing Floyd to finally enlist in the U.S. Army. Private Sheffield's first assignment was to serve as a replacement to the 158th Regimental Combat Team (RCT) "Bushmasters" of the Arizona National Guard. He was assigned to an activated Mexican-American and Indian National Guard RCT. This was the first racial integration done prior to the presidential executive order in 1948.

The first week of August 1945, the 158th RCT was scheduled for a beach assault on a high cliff on Japan's coast, but this was cancelled due to the dropping of the atomic bombs and subsequent surrender of the Japanese. After the Bushmasters' peaceful occupation of Japan, it was determined that if the beach assault had occurred as planned, the casualties for the assault would have been much higher. Bottom line—the dropping of atomic bombs on Nagasaki and Hiroshima most likely saved Private Sheffield's life. Ironically, Floyd's daughter-in-law's mother is a ground zero Nagasaki bomb survivor. At age seven, she saw the aircraft approaching its target just prior to going into the bomb shelter that saved her life.

After a year of occupation duty in Japan, the Bushmasters were deactivated, and Floyd went home to Florida. He opened a twenty-four-hour fast-food restaurant in downtown Panama City on Harrison Avenue. Two years of flipping hamburgers and low job satisfaction led Floyd to reenlist in the U.S. Army Air Corps' new technology field of radar repair. Shortly after this, the U.S. Air Force was created from the Air Corps. Besides two tours in Japan, Floyd was stationed in Turkey, Libya, Canada and finally Tyndall Air Force Base. He retired after twenty-seven years of active service and then went to Haney Technical School for new job skill training. He learned air conditioning repair, opened his own business and then worked for Bay County School Board Maintenance for fifteen years before retiring again. Floyd loved his family, God, his country, the state of Florida and education—in particular, formal education, with Florida State University (FSU) being his favorite. Although he was not able to obtain any formal education beyond the ninth grade, he was a

self-educated man and worked hard to ensure that his children received college educations. In all, his four children received fourteen different college degrees. Six of those degrees (bachelor to PhD) are from FSU. Floyd's greatest love was his wife, Mary Frances Owens, from Geneva, Alabama. They became engaged at one of the first annual Bonifay Rodeos and traveled the world together for over sixty years.

Contents

Preface

With gratitude and appreciation, thank you to the many people of Florida I interviewed and photographed who helped make this book possible. Thank you to Laura Reiley and Hilary Parrish for their help with editing and Amanda Irle for asking me if I was interested in writing *Florida Sweets*.

This book would not have been written without the patience and helpfulness of my husband, Jack, and our son, Jackson; thank you. Jack and I traveled throughout the state looking for something sweet to eat. We found plenty and captured the highlights while regretting we could not visit all the sweet places in Florida. Our son, Jackson, gave much-appreciated advice on where to go and what to include.

Thank you to Lisa Tamargo and her mother, Elisa Morales, for showing me how to make flan; to LeAnn and Charles Knight, Ellen Nafe, Marlene Forand, Hilda Ruiz and Kala DeLeon for their encouragement and helpful advice; and to my taste testers, Tedd Webb, Aaron Jacobson and Jeff Kuyrkendall.

Thank you to my nieces, Hannah Sheffield, who was always willing help, and DeLyn Sheffield McBride, for tinkering with my Key lime pie recipe and their parents, Carolyn and Pat Sheffield, along with Laurelyn and Dennis Sheffield, for their recipes and insights.

My sweet sibling Pat, a sixth-generation Floridian and Florida cracker, gave me his opinion on "What makes Florida so sweet," and you will find his musings at the end of each chapter as a "PS from Pat."

PS from Pat

Growing up in Panama City, I was not a city boy nor was I a country boy—more like a small-town military brat who was fortunate not to face the hardship of constant moving like most other military families. I spent my childhood during the '60s and '70s in Parker, Florida, and was fairly ignorant of the sophisticated ways of life and foods. Our small town revolved around working families, school, military, fishing and church. With the financial help of my parents, I "C"ed my way through Florida State University. After graduation, I went into the family business and became a U.S. Army Infantry paratrooper and subsequently lived in twenty-nine different places worldwide and visited many more. My means of arrival was not always my personal vehicle or Delta Air Lines but by jumping out feet first at one thousand feet above ground level from a U.S. Air Force C-130 or U.S. Army Blackhawk helicopter.

After eating desserts all over the world, I believe good-tasting desserts come from places where people are good and show hospitality. Thus, the best sweet treats come from the Sunshine State. What a great place to eat and live. Despite my actions as a typical younger brother, my good sister made a lot of cookies, brownies and cakes for me and our family. I believe she felt sorry for me because I was not an honor roll student like her and I got into trouble a lot. My favorite part of my good sister's cooking was licking the beaters, bowls and spoons. I was never deterred by my brother, Dennis, telling me that I could get sick from eating uncooked batter or cookie dough. Nowadays, my great wife calls for me to come lick the excess frosting and batter after she has made dessert.

Chapter 1

What Makes Florida So Sweet?

*F*lorida, sweet Florida, where the scent of orange blossoms and honeysuckle fills the air and citrus groves and berry fields color the farmlands.

Sugar-laden Florida is a place where tourists and locals enjoy the plentiful choices of sweets and desserts, from handmade to ready-made creations in restaurants, homes and markets across the state. From the Redneck Riviera in northwest Florida to the Conch Republic of the Keys, the simple pleasures of Florida sweets are found in every corner of the state and vary as much as the land itself.

Key lime pie, Florida flan and strawberry shortcake are a few that top the list of regional desserts. Whether you arrive by air at one of the state's renowned airports, by car at one of the iconic roadside welcome stands or by boat at the pristine ports and marinas, the quaint small towns and the bustling big cities are all part of what makes Florida so sweet. The eclectic atmosphere abounds. From the tranquil oasis of Perdido Key to the bustling beaches of Miami, from the old Florida roadside attractions to the star-studded theme parks, Florida has so much to enjoy and appreciate. My husband, Jack, has lived in Tampa for decades and I grew up in northwest Florida, but that doesn't stop us from taking a Florida vacation or weekend getaway without leaving the state.

How did the state of Florida become so sweet? It took eons of geological development. The first rays of sunshine beamed onto a group of paleo-islands (ancient islands), now a part of the Central Florida Ridge. When

Old Florida postcard with orange blossoms and Bok Tower.

the sand and limestone landmass, what today is called Florida, emerged with the Gulf of Mexico to the west and the Atlantic Ocean to the east, it still took millions of years to create just the right plateau for producing an abundance of sweet edibles. As the waters receded, the shoreline extended across the Gulf of Mexico to the Panhandle. The white, sandy coastal dunes found in northwest Florida are also found in the central part of the state at Lake Kissimmee State Park, with only remnants of an ancient shoreline. Indigenous peoples roamed the area thousands of years ago, from the coastline inland to the Florida ridges in the Central Highlands searching for food. They discovered a few of Florida's naturally sweet wild edibles, such as prickly pears, wild grapes, cocoplums, persimmons, wild berries and sea grapes. For our ancestors, the search for something sweet held more luck than promise.

Ancient Florida ridges consist of several named ridges, with the Lake Wales Ridge being the largest, oldest and highest within the Central Florida Ridge. It runs over one hundred miles along Highway 27 from north of Clermont, home of the Florida Citrus Tower, to south of Lake Placid. Ranging from four miles to fifteen miles in width in places, its elevation reaches nearly three hundred feet at the summit. Although not the highest elevation in Florida, the Lake Wales Ridge is home to many of Florida's rarest and oldest plants and the historic Bok Tower Gardens.

The two-hundred-foot-tall tower is visible long before you near the entrance, creating a picturesque sight that many Floridians in Central Florida take for granted. Every time we drive through the area and see the tower in the distance, I am reminded of the time Jack and I were given an inside tour of the tower by Cassy Jacoby, then promotions director for the park. As the bell ringer, William DeTurk, was describing all that goes on inside the carillon, I was mesmerized by the view while looking out though a porthole-like window from the upper floor of the neo-Gothic Art Deco tower. Viewing the bountiful rolling hills of orange groves, the doxology everyone sang right after Jack and I said our wedding vows, over thirty years ago, came to mind: "Praise God from Whom All Blessings Flow."

Looking out the window, my mind wandered back to a time long before mammals and man roamed the area, when "ancient islands" were perched high atop the Lake Wales Ridge, which today is part of the Ridge Scenic Highway. Nestled among orange groves and rolling hills, its dips and curves carry you along the way to ancient lakes and scrub parks. John McPhee in his 1967 book, *Oranges*, was poking fun at us Floridians when he described the area: "To hear Floridians describe it, [it's] the world's most stupendous

mountain range after the Himalayas and the Andes. Soaring two hundred and forty feet into the sub-tropical sky, the Ridge is difficult to distinguish from the surrounding lowlands." But he redeems himself by paraphrasing the poet Tu Fu to describe the beauty of what he saw while driving the ridge. He wrote that the "orange trees were shaming the clouds."

Venturing through the towns in this part of the state, you will likely happen upon a festival or farmers' market. Another highlight along the Lake Wales Ridge area is a little house nestled within an orange grove. Debbie Crosby, manager of the Grove House visitors' center in Lake Wales, not only welcomes visitors to this cracker-style mini-museum, information center and gift shop, but she and her staff also offer a sample of some of Florida's Natural juices. Closed Memorial Day through the end of September, this seasonally operated Florida orange juice information center is surrounded by orange trees.

You can walk outside with the scent of citrus filling the air or step inside and learn all about the process of bringing a glass of sweet Florida orange juice from the grove to your table. Florida's Natural is a unique

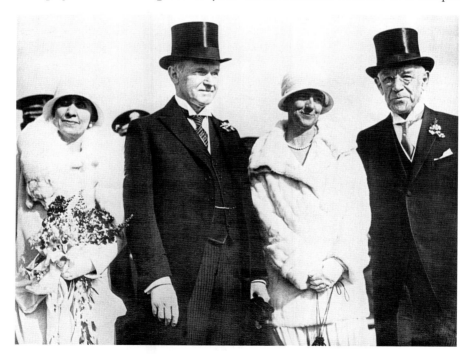

The 1929 dedication of Bok Tower with Mr. and Mrs. Edward William Bok and President and Mrs. Calvin Coolidge.

cooperative of independent citrus growers in the area. A small group of citrus growers joined together to produce the highest-quality juice possible for our servicemen during World War II and led the way in the canning and concentration of juice. Competing for a more natural taste, companies such as Minute Maid in the Orlando area and Tropicana in Bradenton were founded. At the Grove House, a history of the orange juice industry in Central Florida is told through a variety of interactive exhibits as well as a movie and historic photographs.

Following the path of the Lake Wales Ridge, along State Road 17, you can experience a part of Florida oftentimes missed by the faster pace of visitors to the northeast near Orlando with the lures of shopping malls and theme parks. Along the ridge and beyond, we have our own "Citrus Candyland" with shops scattered around the central part of the state. Many have been family owned and have operated for generations.

Thomas Walter Davidson or T.W., as he was called, grew oranges, grapefruit and tangerines in the early 1900s near Dundee, and his son Glen planted his own groves in the area in the 1960s. After serving as a dive bomber on the USS *Valley Forge* and USS *Franklin* carrier ships during World War II, Glen ended up as vice-president for the Sunline (now called Sunmark) Candy Company in St. Louis, Missouri. The company manufactured the ever-popular Pixi Stix, Lik-M-Aid, Spree, Giant Jawbreakers and SweeTarts. In the 1960s, Glen moved back to his Winter Haven childhood home to start his own candy company on Highway 27 in Dundee, near Cypress Gardens. Harvesting the citrus from the many groves Glen and his father owned, they went to work to develop a citrus candy using an old soft-chewy candy recipe.

When Davidson was unable to purchase Taylors Tropical Sweets in Davenport after the owners backed out, Glen started his own candy company, and Davidson of Dundee opened in 1967. The back of a box of the citrus candy reads: "Glen enjoyed a confection made from delicious citrus juices and sugar cane from the Florida Everglades." Glen's son Tom Davidson started working for the company in the early 1980s and became president of Davidson of Dundee in 1995. Glen told Tom, "We have to make the very best we can since we are a small factory, and our customers will remember us and come back to buy more if it is fun to visit our factory, our prices are good and the products are deliciously old-fashioned!" They sell not only citrus candy but also marmalades, jellies, chocolates and coconut patties.

Candies and marmalades are slowly cooked in copper kettles one batch at a time using "sun-ripened fruit and juices straight from the groves with pure cane sugar from the Everglades." Jelly is made with the fruit juice, jam

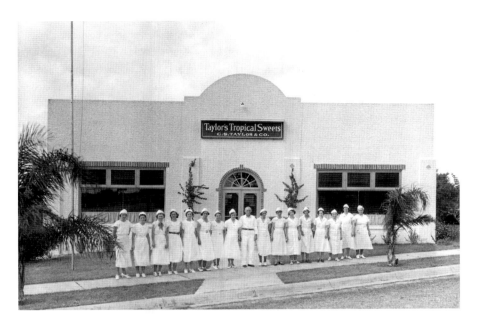

Taylor's Tropical Sweets, Davenport, 1948, of C.S. Taylor and Company. *Photography Robert E. Dahlgren.*

includes the pulp, preserves use whole or chunks of fruit and conserve is fruit mixed with nuts and raisins. Fruit butter is pureed fruit, and marmalade includes the pulp and rinds. Jam, jelly, marmalade, conserve, hand-packaged chocolate, fudge and the sugary sweet Florida citrus candy that "taste like a bite of fruit" are available year-round through the online store. With an on-site old-fashioned candy factory, free tours are offered so folks can not only see how the candy is made but can watch the cutting and wrapping as well. Their unique candy-making process is a part of what makes their candy different. Plus, they offer free samples.

Other stores in the area include Webb's Candy Shop, once located in downtown Davenport and owned by C.S. Taylor in the 1930s. It started out as Sun Dial Citrus Candy Factory, but by the 1970s, Webb's Candies, out of New York, took over and moved the facility west to its present location on U.S. Highway 27. In addition to citrus candy, it has expanded to include chocolates, ice cream, honey, peanut brittle, saltwater taffy, citrus wines and goat milk fudge.

The Haines City area is home to the seasonally open Lang Sun Country Groves and Taste of Florida Café. Mary and Joe Lang opened this shop more than fifty years ago. Today, they offer Mary Lang's award-winning

grapefruit pie, OrangeBerry soft-serve ice cream and other sweet treats. You can even order a Grapefruit Slaw Dog in the café. The old Florida–style gift shop is full of citrus-themed products along with honey, wines, jams and jellies, and they also offer packing and shipping of their Florida citrus. Family owned and operated, Ridge Island Groves offers a seasonal look at their groves and production facility in Haines City or a taste at their Ice Cream Shoppe in Clermont. With a selection of marmalades, honey and jelly, they have been growing citrus on "Florida's Sun Ridge" for over twenty-two years. They have been selling "Paw Paw's" peaches for the last five years. We used ours to make a delicious old-fashioned Florida peach cobbler.

Sun Harvest Citrus in Fort Myers is a fourth-generation family-owned, market-style store with soft-serve ice cream, smoothies, candies and samples of citrus and juice from their Indian River groves. This business began in 1940 when Robert Edsall Sr. planted his first grove in the Indian River district of Vero Beach. In addition to overseeing the groves, family members opened the packinghouse and retail store in Fort Myers, providing customers with a variety of citrus featuring navel, temple, Valencia and honeybell oranges, along with ruby red, star, pink and white grapefruit.

Another little shop, open seasonally, is the Orange Place, in Citra on U.S. Highway 301, north of Ocala. The Ruskin area is home to Dooley Groves, a seasonally open gift shop and self-pick grove with a variety of oranges including clementines, sugar belles, pineapple oranges and tango tangerines. Serving freshly squeezed orange juice, they also pick, ship and pack the citrus for you. Celebrating ninety years of citrus production, John Harvey's Groves in Rockledge, along the east coast near Cocoa, with another store in Melbourne, offers citrus gift baskets for shipping or fresh-picked fruit and other sweet gifts to take home. This family-run business is an example of how the historic citrus industry in Florida survives.

The Citrus Place, at the foot of the Sunshine Skyway Bridge on U.S. 19 in Terra Ceia, is housed in a blue metal warehouse with a brightly colored orange painted on the side. Jack and I stopped by and talked to the founder and owner, Ben Tillett. That sweet storytelling man explained how, with his son Sid's help, they have kept the seasonally open shop in business for more than thirty years. Ben was born on Terra Ceia Island, in the house behind the store. A navy veteran and former English teacher, he left both to manage citrus groves for other people and ended up opening the Citrus Place. Smaller groves were struggling to get by, but working together made it a little easier. Jack bought some freshly sliced orange sections, orange ice

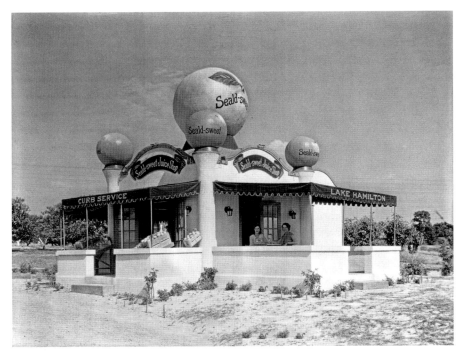

The Seald-Sweet Juice Shop, Lake Hamilton, just north of Dundee. *Photography Robert E. Dahlgren.*

cream and a few other Florida souvenirs that day, but the highlight for me was the conservation with Mr. Tillett.

Mixon Fruit Farms in Bradenton is known for its citrus and orange-swirl ice cream. They also have a large gift shop and café where, for more than seventy years, they have been selling citrus from the same location. What started out as a 20-acre roadside stand is now a 350-acre entertainment and shopping complex featuring a tour through working orange groves aboard the "Orange Blossom Express" open-air tram. You can sample juices, sliced fruit, fudge and wines or just sit a while on Grandma Rosa's porch. Bill Mixon, a third-generation Floridian and pioneer in the citrus industry, started the farm with his parents in 1939. He also wrote *Believers in Action*, a faith-based book filled with memories and stories of his happy life on the farm. The last few times Jack and I stayed in Bradenton at the historic Hampton Inn, we had a taste of Mixon's at the hotel. They offered Mixon's "gator toes" when we checked in—a caramel, chocolate and nut candy—and they had Mixon's orange-swirl ice cream for sale.

For more sweetness, Florida native Debbie Crosby of the Grove House is a natural when it comes to promoting Florida oranges and juice, and one of her first childhood memories is the ambrosia her grandmother made for Thanksgiving dinners. Aside from the citrus tasting at the Grove House, she offers some of her personal sweet spots in the Lake Wales area. Since you can't come to her house for a taste of her mother's red velvet cake, she recommends driving north to Winter Haven for an ice cream cone from Andy's Igloo, open since 1951, or driving a little farther west to one of Lakeland's historic neighborhoods for a slice of locally popular pie at the 1934 Reececliff Family Diner.

The citrus story in Florida is a sweet one. Even our sour oranges contribute their signature flavor to the ever-popular sweet sour orange pie, one that rivals the Key lime in taste. The citrus industry in Florida started with the first seeds dropped or planted as European exploration began. Kings and queens had special orangeries built just to house the plant and protect it from the cold. Now, five hundred years later, the official state fruit is the orange, the state beverage is orange juice and the state flower is the orange blossom. It is fitting for Florida since the orange was once considered a symbol of eternal love, happiness and holiness.

The well-drained, sandy soil and subtropical climate of Florida have provided an area that helps to produce some of the sweetest citrus around. Growing along the central east coast near Titusville and Cocoa Beach, the Indian River and ruby red grapefruit retain a natural sweetness due to the soil and environment along the Indian River shoreline. According to John McPhee, the sweetness of an orange can be determined by its location on the tree. Fruit is sweeter higher on the tree, along the outside and on the south side. It's also sweeter on the blossom end. Ripeness is not determined by color, but consumers are so accustomed to orange oranges that the green ones are used for juicing and other processing. An orange will not ripen once it is picked, yet a green orange can be very ripe, while an orange-colored orange may not yet be ripe. The cool evening breezes help to color the oranges…orange.

In the 1870s, horticulturist James Armstrong Harris took to the task of making the sour oranges sweet, and around the same time, orange grower George L. Dancy began the commercial cultivation of tangerines. In 1910, pink grapefruit was peeled, by happenstance, on the Atwood Groves in the Bradenton area by a foreman named Foster and later propagated by Egbert Reasoner. Douglass Dummett of Merritt Island saved the industry from freezes by the introduction of grafting to produce hardier trees. Citrus

The 1934 Florida Citrus Queen, Marjorie Giddens. *Photography Robert E. Dahlgren.*

was also becoming sweeter and seedless through botanical developments. Today, the sweet-tasting, easy-to-peel, uniquely shaped honeybell orange is a combination of a Dancy tangerine and a Duncan grapefruit.

Oranges were once carried in burlap sacks by horse-drawn wagons to waiting barges to be transported north by schooners or steamboats. The

burlap bags were replaced by wooden crates developed by L.B. Skinner. By the 1880s, railroads were being used to export citrus from commercial groves to other areas throughout North America, with millions of boxes being packed and shipped in the early part of the 1900s. Skinner and A.L. Duncan were early citrus growers in Dunedin. Duncan is noted for introducing a sweeter grapefruit, and Skinner's son Bronson was one of many instrumental in the development of concentrated orange juice. Prior to that, fresh-squeezed orange juice was easily made at home, but once squeezed, it deteriorated rapidly. Canned was another option. Donald Duck orange juice, with a Disney-approved picture of the celebrity duck on the can, was a product of Citrus World, which became Florida's Natural Growers.

By the mid-1940s, the Florida Citrus Commission and the United States Department of Agriculture had developed frozen concentrated orange juice that tasted nearly fresh when reconstituted. Most children of the 1950s remember those tiny cans of frozen concentrated orange juice and the deliciousness inside. By 1957, Minute Maid was the largest manufacturer of concentrated orange juice (they also produced Hi-C, a canned fruit drink). It moved its headquarters from New York to Orlando. Bing Crosby and Anita Bryant sang its praises, reminding everyone that "A day without Florida orange juice is like a day without sunshine."

In 1958, the Minute Maid Governors' Grove in Clermont was established for each governor of the United States and territories to have an orange tree on a four-hundred-square-foot patch of land, from which the citrus from their tree would be picked and shipped to them each year. The grove is gone, but the Florida Citrus Tower, in the geographic center of the state, with its 360-degree view of eight counties, still remains as a reminder of what that part of Central Florida once looked like. Rolling hills of citrus groves are now replaced by housing developments, but the citrus industry has always been a part of what makes Florida so sweet and is an integral part of the image of the state.

The industry went from bottling plants to concentrated frozen juice and back to fresh squeezed as refrigerated cartons of flash-pasteurized chilled juice were introduced by Florida's Natural brand. At one time, orange baron Ben Hill Griffin had his own concentrate plant, which John McPhee likened to "having your own turnpike, or your own air force, or at the very least your own country." Today, oranges are still handpicked in the field and then loaded into trailers and delivered to processing plants. Once they are dumped onto the conveyor belts, the washing process begins. The oranges

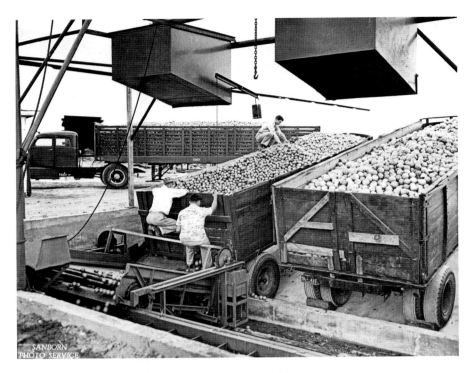

The unloading of fruit at a concentrate plant, circa 1953.

are graded and sorted, with the less perfect ones used for something other than juice, such as cattle feed or orange oil. Florida's Natural represents one thousand grower-owners and more than sixty thousand acres of citrus groves. As it says on its website: "We own the land. We nurture the fruit. We harvest it at peak ripeness. Then we squeeze every delicious drop ourselves before bringing it to your table."

Many citrus places tend to be open seasonally when the fruit ripens. If you plan to visit an orange grove or shop, I recommend you call first, even if the website states they are open. You can use your fresh citrus in a variety of ways, but ambrosia, known as "food of the gods," is a common Florida dish served as a dessert, appetizer or side dish. The recipes vary according to tastes and location. Debbie Crosby's grandmother used oranges, grapefruit, canned or bagged coconut and sometimes maraschino cherries cut in half. And to please an uncle, pecans were added. Marjorie Kinnan Rawlings, writing in *Cross Creek Cookery*, also used chopped pecans, along with freshly grated or canned coconut, but she added tangerines instead of grapefruit

and powdered sugar for more sweetness. Some recipes use only oranges, and sugar is added as needed.

Juicy and sweet, fresh Florida oranges can be enjoyed, along with easy-to-peel tangerines and jumbo grapefruit, from approximately October through May or June and sometimes as late as July. Each type of citrus has its own season, and some varieties vary as well. Hamlin oranges and tangerines are frequently the first on the market, followed by tangelos and navel oranges, then the pineapple-orange and temple and lastly the Valencia orange. Florida welcome stations, as well as seasonal grove shops, give out free samples of fresh-squeezed juice as a sweet treat.

PS from Pat

My number-one favorite cookies my good sister makes are snickerdoodles. My mom almost always cooked supper from scratch. Likewise, desserts were from scratch too. Usually it was my good sister's task to make a dessert such as brownies, cakes or cookies for the family meal. A preseason opening-day fish fry for youth sporting events, family reunions, church dinners (dinner means lunch for non-southerners) and one visit to Captain Anderson's Restaurant were about the only times we ate something outside the home. At the restaurant stop on the way back home to Florida, the waitress brought what looked like one large scoop of ice cream before our main meal along with our water. Dessert before the main meal—I was elated. With four kids at the table, Mom could not watch us all at once. With my spoon, I got a large lump of vanilla ice cream, and with that first sweet taste, I realized the hard way that butter does not always come in the form of a stick.

Chapter 2

Festivals, Fairs, Parks and Picnics

florida is rich with sugar and tropical fruits to the south, citrus starting around the central part of the state and berries and honey throughout the landscape. And there are grapes, persimmons, watermelon and much more to add to the bounty. Today, it's an edible marketplace with all of the festivals celebrating Florida's natural resources, yet it's still an adventure discovering what makes Florida so sweet. Combine that with the talented pastry chefs and home cooks and you will find culinary sweets lurking in every corner of the state. From the sandy uplands of the Central Florida Highlands to the hidden middens along the coast, Florida's geological metamorphosis helped to create a land laden with natural resources both savory and sweet. It's the sweet ones that garner the most attention.

Prehistoric men weren't making s'mores, since sugar, chocolate and wheat were not natural resources at the time. There were no marshmallows roasting over an open fire, but they did collect wild fruits and berries and used spears to hold foods over fires or hot coals. Holding a prickly pear cactus fruit over a flame on a palmetto stem skewer, in order to singe the irritating, hidden glochid off the fruit, would have been a natural way to make it easier to work with. Today, we use tongs to hold the fruit over a gas cooktop or other open flame to burn off the glochids before making that sweet edible fruit into syrup, jelly, pie, wine or even ice pops. Prickly pears have historically been made into pies and served by early Florida settlers but more recently used to flavor gourmet ice pops. Closing the gap between the Ice Age and the Space Age by using prehistoric ingredients, with changing flavors such as

sea grapes and prickly pears, combined with the latest technology for rapid-freezing techniques, gourmet fresh fruit ice pops are now commonly found throughout the state.

Traveling from the Atlantic coast to the Gulf of Mexico in dugout canoes along Florida rivers has been replaced by motor homes and autos along highways and backroads, bridges and ferries. These scenic roads and even the interstate highways and railroads have followed historic paths across the state of Florida for us now to explore in air-conditioned comfort. Today, throughout the Sunshine State you will find historic markers, local museums, parks and relic mounds that yield vast sources of information about the lifestyles of early Floridians. They serve as historic guideposts for learning more about the geography, history and foodways of Florida.

We drive by, walk over, picnic in or swim around many of these archaeological sites unaware of the information they provide, in such places as Silver Springs, Wakulla Springs, Warm Mineral Springs, Weeki Wachee Springs and Homosassa Springs. Now these former homes of ancient Floridians are favorite gathering spots for locals and tourists licking ice cream cones or slurping slushes as they roam about looking for entertainment. Many state and local parks offer insights on the history of the area with historic markers, making the information easily available to Floridians and tourists alike. Today, we have more than 150 state parks that include one hundred miles of beaches.

The creation of the Florida State Park systems began in the late 1800s when the Florida legislature created a commission to plan the placement of monuments to honor those serving in battles across the state. The first was at Olustee, in Baker County. Later came Highlands Hammock, one of many parks created or improved by the Civilian Conservation Corps (CCC), a federal Depression-era program to provide employment for the nation's young men between the ages of seventeen and twenty-five. Run by the army in a military-like manner, the CCC developed eight parks from 1933 to 1942. With rustic-style construction and craftsmanship, you can still see some of these buildings at Highlands Hammock in Sebring. They constructed the concession building, visitors' center, roads and bridges. Today it is home to the State of Florida CCC Museum, with memorabilia, photographs and videos. Located in the 1939 CCC building, the museum displays the Thanksgiving dinner menu for the men, listing for dessert fresh apple pie à la mode and chocolate cake along with mixed nuts and candy. The spring menu dessert suggestions include chocolate cottage pudding, Cape Cod cookies, coconut pumpkin pie and cinnamon tarts.

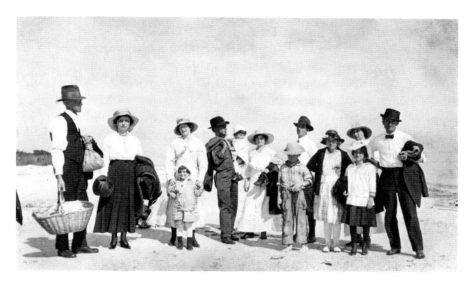

A picnic at Fort Myers Beach in 1920.

Weeki Wachee, with its sparkling spring waters and historic mermaid show, previously owned by ABC television network, is now a part of the Florida State Parks system. This relic of the past has welcomed tourists for over six decades. Located on what was once a lonely highway six decades ago, today the bustling six-lane U.S. 19 takes you back in time to an old Florida theme park. Costumed mermaids entertain under water while others delight in the only spring-fed water park in Florida.

The sylvan respite around the park was inviting, so Jack and I drove west down Cortez Boulevard, just north of the park, to explore an area we hadn't yet discovered. We didn't let the "bear crossing" signs slow us on our way to Bayport Park. Turning onto Pine Island Drive at the Bayport Inn, only after stopping by for a slice of Key lime pie, we discovered an area of sawgrass and palm trees along a canal leading to the Gulf of Mexico and the county park.

The county and state parks system of Florida has such a variety of environments, from the mermaids of Weeki Wachee to the filming location of *Creature from the Black Lagoon* in the 1950s at Wakulla Springs State Park. This enchanted area, with all its ancient and recent history, offers glass-bottom boat tours of the crystal-clear springs with relics from old movie sets and the historic Wakulla Springs Lodge. Today, the Mediterranean-style lodge, located within a National Historic Landmark area, features fresh

fruits and assorted pastries for breakfast in the Edward Ball Dining Room. Hidden around the corner and tucked behind an outdoor spiral staircase is the entrance to one of the world's longest marble-topped soda fountains, where they have been dishing out ice cream for decades.

The beaches and state parks of Florida are not only the perfect picnic spots but have also provided locations for shooting films and television shows, so much so that Florida was once referred to as "Hollywood East." In 1954, Wakulla Springs was home to the filming of *The Creature from the Black Lagoon* in 3D. Some other films include *Tarzan's Secret Treasure* in 1941, *Night Moves* in 1975 and *Airport 77* in 1977. Weeki Wachee hosted the filming of *Mr. Peabody and the Mermaid* in 1948. Across the state at Silver Springs, some of the movies filmed on location include *The Seven Swans*, a silent movie, in 1917; *Distant Drums*, with Gary Cooper, in 1951; *Jupiter's Darling*, starring Esther Williams, in 1955; and six Tarzan movies.

Another place to absorb the history of Florida is Historic Spanish Point, in Osprey on the Tamiami Trail. This thirty-acre historical and environmental site that extends into the waters of Little Sarasota Bay is one of Florida's

A picnic in July with watermelon at Jacksonville Beach in 1973. *Photography Karl E. Holland.*

premier archaeological spots. With its prehistoric Calusa Indian burial and ceremonial mounds, Spanish Point offers visitors the chance to rediscover five thousand years of history with "A Window to the Past," the only archaeological exhibition in the nation built inside a shell mound. This park showcases Florida from its prehistory to the pioneers who helped to create the "old Florida" we have come to know. Some of the first settlers of Florida began exporting citrus and sugar cane to the North, and that spread the word about the sweetness that could be found in the state.

From the Kumquat Festival in Dade City to the Holiday Fresh Market in Apalachicola and south to MangoMania Tropical Fruit Fair in Cape Coral, the state appears at times to be one big playground for year-round festivals celebrating the natural resources of Florida. Seasonal bounty and fertile grounds determine the location and times of these festivals. Some festivals come and go, while others have been a part of the Florida landscape for decades. There is a sugar festival in Clewiston, a sugar cane festival in St. Augustine and a Long Cane Syrup Day in the tiny town of Two Egg. Orange festivals and sour orange festivals are among the list, as well as pumpkin, tropical fruit, pineapple and peanut festivals. There's a honey festival in LaBelle and a tupelo honey festival in Wewahitchka, which features the star (well, the honey, not Peter Fonda) of the motion picture *Ulee's Gold*, filmed in that area. There are ethnic festivals, chocolate festivals, a flan festival in Tampa and a pie festival in Orlando. Watermelons, blueberries and strawberries all have their own weekend or weeklong celebrations.

St. Joseph, in Pasco County, has been known as the "Kumquat Capital since 1895," and nearby historic Dade City hosts the Kumquat Festival around January. Lunch on Limoges located in Dade City serves seasonal desserts such as kumquat cake in a unique atmosphere. Phil Williams and Skip Mize have created a restaurant located within Williams Fashion Center, which the Williams family has owned since 1908. The display of desserts is ever changing and mouthwatering. The Kumquat Growers, Inc. website, kumquatgrowers.com, features recipes for cakes, pies and other kumquat-based dishes.

Pies, pastries, marmalade, jams, cookies, cakes, smoothies, salsas, syrups, ice cream and samples of local kumquats are all a part of the festivities. In 2016, the Kumquat Growers Open House was held before the festival at the Kumquat Growers Packing House, where fruit is processed and shipped out to other markets. This tiny orange orb can sometimes be harvested as early as October, but November through March is more commonly the season. Native to China, the name *kumquat* means "gold orange" in Chinese. Eaten

whole, the fruit has a sweet and tart flavor, but unlike other citrus, the skin provides the sweetness next to the tartness of the pulp. The Nagami variety is an oval kumquat and the most popular variety grown in Florida. Introduced to Florida from Japan in 1885, the pulp contains green seeds that need to be removed before cooking or eating whole. Eastern Pasco County is a natural environment for growing the best kumquats in the state.

Hillsborough County is home to two historic festivals every year: the Florida State Fair in Tampa and the Florida Strawberry Festival in Plant City. The manager of the 1891 Tampa Bay Hotel appealed to the city to host the South Florida Fair on hotel grounds in 1904. The hotel was built by Henry Bradley Plant and located at the end of his rail line, which made it convenient to bring the fair to the hotel grounds. In 1915, what became known as the Florida State Fair outgrew several locations before moving to its permanent home. With over ninety years of celebrations, this twelve-day fair still features popcorn and pie baking contests, but the midway offers a variety of new and trendy fair foods such as bacon ice cream and deep-fried birthday cake pops. The fairgrounds are also home to the Cracker Country Living History Museum.

Following in late February or early March, Plant City, the "Winter Strawberry Capital of the World," has hosted the largest strawberry festival in the state since 1930. For a taste of fresh-from-the-field strawberries in

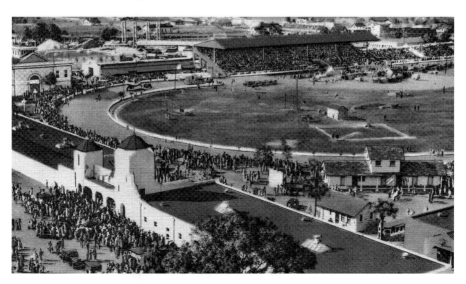

Bird's-eye view of the Florida State Fair in Tampa, circa 1940. *Hillsboro News Co.*

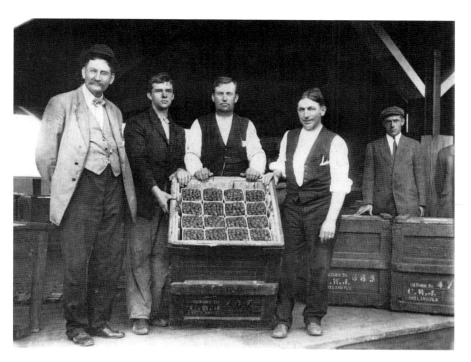

Left to right: A.J. McKinney, Joe Jerkins, Oscar J. Pope and Charles W. Jacobs posing with a crate of strawberries around 1910.

shortcakes, shakes, pies and cobblers, this slice of Americana is served up in an old-fashioned carnival atmosphere. Even though the first strawberry cakes were most likely created by Native Americans, combining cornmeal with strawberries and then baking, it was the colonists who took it a step further to create the strawberry shortcake. In 1999, the Plant City Strawberry Festival was home to the world's largest strawberry shortcake, making it into the Guinness Book of Records.

The peak season for strawberries in Florida is usually February through March, although the season at times runs from November through April. Fear of frost and freezing temperature brings out the all-night vigils and water sprinklers to create an ice coat to protect the fruit beneath from further freezing in order to bring these delicate and delicious gems to your market and table. The area was originally named Ichepucksassa after an Indian village but was changed by the postmaster to Cork due to the difficulty in spelling and pronunciation. In an homage to Henry Bradley Plant for bringing the railroad to the area in order to deliver produce and

strawberries to the market in timely fashion, the name was once again changed to Plant City.

Strawberry farming is a way of life for farmers and their families in Plant City. At one time, "strawberry schools" were established in the area, with schedules to accommodate the harvesting times so children could help out in fields when the strawberries were ready to be picked. That ended in the 1960s, when students in the area began to attend school on a schedule with others in the county. Strawberries are still manually and individually picked when ripe and then carefully placed directly in the plastic containers you purchase at the market just days later. It is almost as if the hardworking migrants in the fields are placing these delicate berries directly on your table. High in Vitamin C and full of antioxidants, strawberries are a part of the rose family, which might account for their heavenly smell. If you miss the fair, you can get a taste with a visit to Parkesdale Farm Market just down the road from the festival site. Parkesdale Farms was founded by R.E. "Roy" Parke Jr., who emigrated from Northern Ireland to Pennsylvania in 1924 with his family. In 1956, the family relocated to Plant City, and in February 1969, Roy's daughter Cheryl and her husband, Jim Meeks, opened Parkesdale Farm Market (www.parkesdale.com).

Blueberry festivals, around April and May, provide an opportunity to sample and buy local berries to eat whole or take home and bake in a grump, slump, cobbler or crisp. Pancakes, pies, jams and jellies are all wonderful ways to cook using healthy blueberries. They contain more antioxidants than most other fruits and vegetables. If you want to store the berries in the freezer for later use, just wash them before placing in a single layer on a cookie sheet. Put them in the freezer, and when frozen, they can be placed in plastic bags and kept in the freezer to use as needed. If you are using them in batters, it is best to stir them in last to keep the berries whole.

Blueberries have been growing wild in North America for thousands of years, and they were a part of the Native Americans' diet when European explorers arrived. Wild berries were growing in Florida in the 1800s, and now there are blueberry farms across the state. Florida berries are the first of the season for North American blueberries. Some of the charming small towns where you are likely to find a blueberry festival in the springtime include Brooksville, Davenport, Bronson, Hudson, Mount Dora, Plant City, Avon Park, Bostwick, Island Grove and Wellborn.

Summertime is watermelon time in Florida, as it has been for generations of Floridians. All across the state, roadside stands and gourmet restaurants sell or serve this nutritious, red, delicious, juicy fruity cucurbit. Watermelon

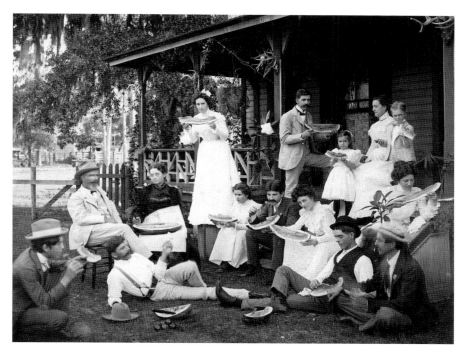

A family eating watermelon in Tampa on Franklin Street during the 1800s. *Photo on loan from William Gladwin.*

is considered a fruit or a vegetable. Either way, it's packed with vitamins and powerful antioxidants, containing over 90 percent water, which makes it a refreshing hot weather treat.

Historically, watermelons have been found from Africa to Egypt, including in King Tut's burial tomb, and along the Mediterranean Sea all the way to China and later in Europe. Spanish explorers found Native Americans growing them in the late 1500s. Once considered a water source or natural canteen for the hot and dry desert climates or long ocean voyages, today it is served as a dessert or snack. Thomas Jefferson, an American founding father and the principal author of the Declaration of Independence, grew watermelons at his legendary home and garden, Monticello, in Charlottesville, Virginia. By the early 1900s, Monticello in Jefferson County, Florida, was producing 80 percent of the world's supply of watermelon.

Weeks of grueling work in the fields, lifting these five- to fifty-pound melons to bring them to market, is preceded by handpicking, cutting along

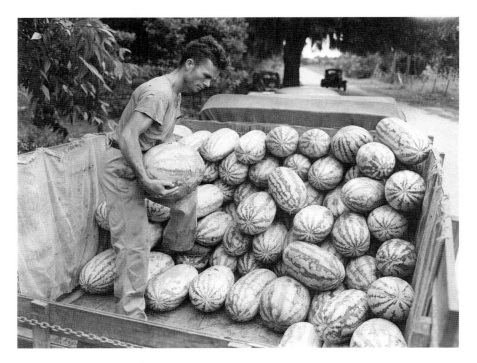

Donald Fort, a marine, loading watermelons at Oxford, Florida, in 1947.

the curly tendrils and hairy vine and then loading and packing for shipment or local sales. This all-American part of the summertime scene was once associated with the outdoors, from the front porch to the backyard, at the beach or on a picnic or any place you could easily rinse off the juice running down your chin to your arms and beyond.

Each luscious bite into its bright red sweet center was oftentimes culminated by a seed-spitting contest. Now, the melons are mostly seedless and come already sliced or cut into bite-sized pieces for convenience. But you often see them whole, in a spring or tub of ice, at outdoor celebrations on Memorial Day, the Fourth of July and Labor Day. When selecting a whole melon, one easy way to determine ripeness is to look at the bottom where it rested on the ground. It should be yellowish-cream to indicate ripeness; if it's green or white, the melon is not ripe. The variety of melons is celebrated with names like revolution, fascination, exclamation, jubilee and stars-n-stripes, while a couple of the hybrids are called sugar baby and orange sunshine.

Watermelons are a part of small-town charm and summertime festivals, from Chiefland, Chipley, Arcadia and Newberry to Monticello. Since 1949, the third week of June in Monticello has been the time for seed-spitting and watermelon-carving contests. The first Saturday in June begins the celebrations for the Chiefland Watermelon Festival with parades and a Watermelon Queen, along with tubs of ice-cold watermelon. The Newberry Watermelon Festival held in May 2016 was its seventy-first celebration, and the quaint town of Chipley holds its Panhandle Watermelon Festival in June.

PS from Pat

Eating Florida watermelons on the Fourth of July or hot days of summer was great. My dad was always the best selector of the perfect watermelon. Salt was used to provide a delicate blend of salty and sweet. We had to eat outside and preferably on the screened-in porch so the flies would not attack the slices of watermelons. Spitting seeds was the most enjoyable part of eating those big Florida watermelons. My childhood friend Steve taught me how to spit seeds farther by placing my pointer and bird fingers perpendicular across my lips and leaving a small opening to let the seed shoot out. I am 100 percent sure he didn't actually say the word "perpendicular" though. He showed me how to spit.

Chapter 3

Pies Across the Panhandle

Honey, sugar, pumpkin, sweet potato, sugar plum, dumplin' and sweetie pie are not only a part of southern sweets; they are also terms of endearment across the South, and North Florida is no exception. Alabama and Georgia are as big an influence on the North Florida cooking culture as the Caribbean is to South Florida dishes. As a result, the northern part of the state has the most defined southern roots. The boundaries are oftentimes blurred when it comes to family celebrations, reunions, cookouts and dining in general.

Pies across the Panhandle reflect more southern flavor, with a colonial influence, than those in the southern part of the state. Pies were much easier to create with a simple biscuit crust and fruit or jam filling, but cakes required exact measuring and precise baking temperatures. Homemade cakes, lovingly made with local ingredients, using recipes shared and prepared in unique ways as interpreted by generations of bakers, have graced the tables of Florida families for decades. One of my favorites is the multi-layered caramel or chocolate cake, with as many as fifteen thin layers covered with sweetness. This labor of love that our south Alabama relatives shared at many celebrations was time-consuming to make. Preparing the chocolate or caramel icing was as demanding to "get just right" as preparing the many layers, one at a time in a flat-iron skillet. Other family favorites included the newcomers: red velvet cake, Italian cream and hummingbird cake.

And then there is my father's favorite, Lane cake, another south Alabama tradition, with an egg yolk filling packed with pecans, coconuts and raisins.

My mother's favorite was always a toss-up between sour cream pound cake, fruitcake and a lemon curd–filled fluffy frosted cake with coconut pressed onto the sides and tops. I discovered the reason that no one could re-create her cake from a recipe: she used several recipes to make one cake—one for the cake, one for the filling and another for the frosting.

Wright's Gourmet House in South Tampa is my favorite place for cakes and cupcakes similar to those I remember from my childhood. Opened in 1963 by Marjorie and Pete Wright as a coffee and dessert shop, today Wright's Gourmet Café serves sandwiches, salads and desserts. They are most noted for their consistently scrumptious cakes and cupcakes, including Alpine, carrot, coconut, chocolate, hummingbird, red velvet, peanut butter chocolate and Hawaiian princess.

Our family reunions in the '50s and '60s offered cakes, but my favorite desserts were the pies. Always displayed on a table near the cakes, there were pecan, peanut butter, sweet potato, lemon, chess and chocolate, with pumpkin for Thanksgiving. Pecans came from the nearby trees, and pumpkin was probably from a can. Sweet potatoes were from the garden,

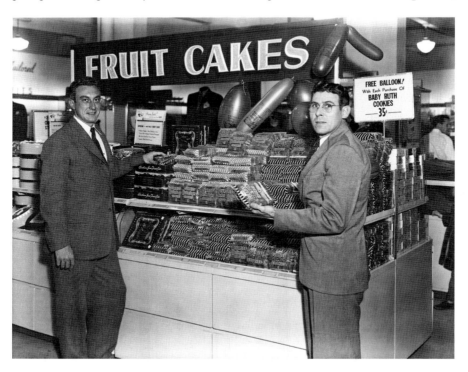

The Curtis Candy Company fruitcake display in Jacksonville, 1947. *Spottswood Studio*.

and knowing how to select the sweetest made for an even more delicious pie. It was impossible to pick a favorite; a tiny slice of each was required. The thick layer of sugary goodness beneath the pecans was where I started, and I ended with a slice of chess pie and then went back for more if I was still undecided on which one I liked the best. We children ran around a lot in the yard after eating and, on the hour-long drive back home, usually fell asleep in the car.

But life in the Panhandle wasn't always so sweet. As the prehistoric period in Florida came to an end, the Columbian Exchange brought cultural diversity to the area in food choices, cooking style and manners. Old-world fruits such as peaches, watermelon, figs, grapes, limes, lemons, oranges, pomegranates and pears were introduced by Spanish explorers. From South America came papayas and pineapples. Before sugar cane was popular, Native Indians used honey to sweeten dishes. By the end of the sixteenth century, the culinary diversity included everything one needed to make jumbles, slips, fools, flummery, rusks, puddings, trifles and duffs, with swine, sugar, cattle, honey, chocolate and eggs. By the late 1700s, cookbooks were influencing dishes throughout the country.

The British period in Florida, from 1763 to 1783, had a big impact on southern cooking. From the brick ovens in historic Pensacola Village to the beehive bakers in St. Augustine, baking desserts became a part of our celebrations and special occasions. Refrigeration and air conditioning were a long way off, but hand-cranked ice cream churns were introduced to the country around 1780. It took much longer before they became common in the heat-riddled state of Florida. By the time George Washington became president, Florida was still considered untamed wilderness.

The Americanized version of pie introduced the sweet dairy-based pudding as a filling with many ingredients found in the farm yard, fresh cow's milk with cream on top, hand-churned butter and henhouse eggs. Today, with an abundance of citrus, nuts and berries along with sugar cane and honey, the combinations seem endless. Pudding baked with a crust led to an American favorite, the iconic pumpkin pie. Although the English considered pumpkin a poor man's food, early colonial-influenced cookbooks carried recipes for a pumpkin pie similar to a pudding. Following the path of pudding through a succession of old recipes, one can see the changes in technology and ingredients that influence cooking methods and ingredients of puddings and pies today.

Susannah Carter devoted an entire chapter in her 1792 cookbook, *The Frugal Housewife*, to puddings. In 1796, Amelia Simmons wrote the mother

of American cookbooks, *American Cookery*, the first cookbook to introduce American ingredients in the recipes. Five recipes using cornmeal, a native ingredient, were included: three recipes for Indian pudding, one for johnnycake or hoecake and one for Indian slapjacks. The Indian pudding served today at Boston's historic Durgin Park, one of the oldest continually running restaurants in the country, is prepared much the same as it was all those years ago, with molasses as a sweetener. A similar version, called hot Indian pudding, is served at the historic Union Oyster House just around the corner from Durgin Park.

But it is Simmons's pumpkin pie that has had the most significant impact on tables across the country, making it the traditional pie served every Thanksgiving. Here in Florida, we grace the table with pumpkin pie out of respect for tradition, but a Key lime pie is never far off. Simmons's pumpkin pie recipes went through a metamorphosis from her first edition to her second. First baked in a crust and then a puff pastry, the eggs went from nine to six, cream was replaced by milk and the pumpkin went from stewed to strained. Her recipes included the usual sugar and spices of mace, nutmeg, allspice and ginger, along with molasses in one version. For early colonists, pumpkin was often the difference between survival and starvation. The colonists quickly overcame the prejudice that pumpkin was fit only for peasants.

The Art of Cooking by Hannah Glasse in 1805 featured recipes for baked custard, pudding pie, egg custard and pumpkin pie, instructing one to peel the rind and then stew the pumpkin until soft before adding the remaining ingredients of milk, wine, rosewater, eggs, nutmeg, ginger, sugar and salt. Lydia Marie Child, in her 1833 cookbook *American Frugal Housewife*, offered recipes for baked Indian pudding and boiled Indian pudding, which included cornmeal, also called "Indian." A more recent recipe for Indian pudding using cornmeal is found in the 1953 *American Woman* cookbook. A combination of milk, molasses, yellow cornmeal, ginger, ground cinnamon and butter is stirred and cooked before being baked for about an hour. And then there is the mother of regional American cookery, Mary Randolph, who wrote *The Virginia Housewife, or Methodical Cook* in 1824. In it, she gives instructions for pumpkin pudding: "stew it, sieve it, mix it with eggs, butter, milk, ginger, nutmeg, brandy, and sugar to taste." After putting it in the pastry shell, "cut some thin bits of paste [pastry], twist them, and lay them across the tops, and bake nicely."

Sago or arrowroot is an ingredient in one of the most authentic Florida puddings or pies of the past. The native plant *Zamia floridana* is also known

as Seminole bread, coontie or Florida arrowroot. European settlers used it as a substitute for the difficult-to-obtain wheat flour. The starch was obtained from the rootstock of the plant through a laborious and tedious process. It's remarkable how Florida's indigenous people and later cracker settlers perfected this time-consuming process to extract the edible starch from the toxic plant for making breads, biscuits, cookies and puddings. Once the root was dug up, it had to be pounded, cut up, crushed or grated. Then it was soaked and/or washed several times and strained to let the starch settle from the pulp. It was rinsed again before the resulting paste was left to ferment and then dry to a powder in the sun. By 1845, small coontie mills had sprung up over South Florida, and a booming business was born. One recipe in Randolph's *The Virginia Housewife* is for a pudding of milk and arrowroot with six eggs, butter, sugar, nutmeg and a little grated lemon peel to be baked and topped with sifted sugar and garnished with citron.

The 1912 community cookbook *The Florida Tropical Cook Book*, created by the Aid Society of the First Presbyterian Church in Miami, used its proximity to the Florida arrowroot source as a reason to include suggestions and rules for using Florida arrowroot starch, stating, "Children are especially fond of the various desserts made from this wholesome starch." The book also noted, "In ice cream custards this starch excels others. Try it and see how creamy it makes the ice cream," and "When you wish to make fruit jellies or transparent desserts nothing is so nice as Florida Arrowroot Starch." The cookbook was created to answer questions about the fruits and vegetables some cooks had never seen before arriving in South Florida. "Now tell me how to prepare it for the table....The reiteration of this question has prompted us to undertake the compilation of the recipes found between these covers." There were original old family favorites perfected through trial and error during their early years in Florida, and all were tested by the pioneer women of Florida, "to whom we desire to express our appreciation of their kind contributions."

Following the path of a recipe to see how the cooking styles were adapted to the environment based on ingredients and methods available and searching for the roots of many popular dishes that harken back to pre-colonial days helps to uncover the foundation of great southern cooking. Much can be credited to the Native Americans and the Spanish for introducing corn, the one ingredient that influenced everything from a simple snack to hearty desserts. This leads to a great pie debate: the origin of chess pie. Does it require cornmeal for that authentic flavor, or was cornmeal once again a substitute for wheat flour found in later versions of the recipe? Was it at one

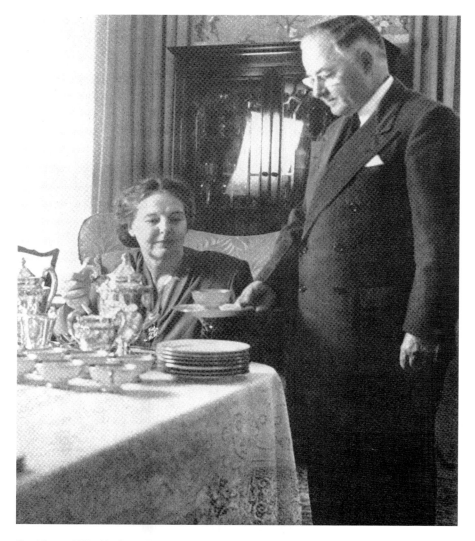

President of Florida State University Dr. Doak S. Campbell with his wife serving tea, circa 1948.

time called cheese pie, with a British lemon curd or cheese-like filling, with the Americanized version of cheese calling it chess? John Egerton, author of *Southern Food*, speculates that the name originated with the southern dialect of leaving off the end of a word, converting it from chest pie to chess pie, referring to the pie safes or chests in which the pies were stored before refrigeration.

In the 1950 Tallahassee community cookbook *Camellia Cookery: Tallahassee's Favorite Recipes*, Mrs. Doak S. Campbell, wife of the president of the Florida State College for Women and later the co-ed Florida State University, includes a handwritten recipe titled "My Mother's Cheese Pie" but notes that today it is called "Chess Pie." Campbell instructs the reader to cream together one cup of butter and two cups of sugar before adding eight well-beaten egg yolks to the mix. A tablespoon of flour is added, and then the whipped yolk of one egg is folded in. She flavors her pie with nutmeg and vanilla, and then the filling is poured into an unbaked pie crust to be slow baked; it is up to the reader to decide how long. She does caution, "Bake slowly and be careful not to overcook. Eggs cook quickly."

Years ago, going out to dinner and ordering dessert was reserved for special occasions, unlike today when a home-cooked meal seems to be a special treat. The only restaurant dessert that stands out in my recollection of growing up in Panama City is the pecan-laced and whipped cream, layered feud cake served at Captain Anderson's Restaurant. Jimmy and Johnny Patronis made it famous with enthusiastic advertising in the 1960s, and it is still on the menu today.

Now, a hometown favorite for desserts is Sweet Magnolias in Millville, a small community near Panama City. Owned and operated since 1989 by Kathy Hanline and her close friend Sherry Groom, this duo has created an almost cult following for their homemade desserts. Groom told me she sees more people enjoying desserts now than ever before and credits the popularity of their pies and cakes to the high-quality ingredients and time-tested recipes that she grew up with. Peanut butter and Key lime pie are almost always on the menu, but their cakes are just as good. My brother Pat's favorite is the lemon blueberry cake. Also included on the dessert tray on our most recent visit were hummingbird cake, coconut cake with an old-fashioned seven-minute frosting and a multi-layered caramel cake.

Heading west to the coastal community of Fort Walton Beach, you will find Sugar Mill Sweets Bakery. Jason Hendrix, a former police officer, and his brother William Waller run the restaurant and bakery that was started by their mother, Rebekah Miller, and her sister Annette Putnam. Jason is in charge of the desserts and was dubbed the "Cake Boss" by *Emerald Coast Magazine* in the June/July 2012 issue. The morning I arrived, Jason had just pulled a luscious-looking peaches and cream pie out of the oven. It had a cake layer on the crust, followed by peaches and then cheesecake, topped with cinnamon sugar. Peaches originated in China, but the first peaches in Florida were probably brought to the northwest Florida area by the French

around 1562. Spaniards later introduced the fruit to the St. Augustine area, and today, peach orchards are making a comeback throughout the state. In the past five years, Florida-grown peaches have begun to show up at markets from about the middle of April to the end of May. Other pies on the menu that day were the southern classics of coconut, pecan and sweet potato, along with the state pie of Florida, the Key lime.

Key lime pie has now taken a well-deserved spot on most Florida dessert menus and even doughnut shops. It was advertised on the marquee at the DoNut Hole, a popular breakfast, lunch and sweet shop since 1978, with locations scattered along Highway 98 from Destin east to Inlet Beach. I found a delicious slice of pecan pie at the Inlet Beach location along with Key lime, chocolate cream, coconut cream and peanut butter. They also had assorted cakes and, of course, doughnuts. Traveling from one DoNut Hole to another, you will pass Grayton Beach State Park. At one time an isolated area, the small town of Grayton Beach is home to the popular and unique Red Bar. Housed in a former general store and Saturday night dance hall in the 1940s, it is indeed a memorable spot and, according to them, serves the best Key lime pie in the Panhandle.

Palafox Market in Pensacola, held on Saturdays, offers many home-grown or locally made sweet selections, including baked goods, kettle korn, jams, honey and pies. All vendors are from within a one-hundred-mile radius of the area, which includes parts of Alabama, so I felt it fitting to mention the pie lady, Marlene Lockett, of Seasons on the Gulf. When we visited the market, she had rolled out over 160 pie crusts the day before in her Foley, Alabama home. Offering a taste of her sweet pie crust and seasonal pie selections, the orange-flavored sweet potato was a clear choice for the day. Chrisoula's Cheesecake Shoppe was selling cheesecake on a stick, which made shopping and tasting an easy endeavor. Just a few blocks from the market, on Palafox Street, is Adonna's Bakery and Café, recommended by my niece and a University of West Florida graduate, Hannah Sheffield. For more sweets, just down the road is newcomer Bubba's Sweet Spot and time-tested Jackson's Steakhouse overlooking Plaza Ferdinand, where General Andrew Jackson accepted the transfer of Florida from Spain to the United States.

As a home economics student at Florida State University, we occasionally drove south for dinner. This area, known as the Forgotten Coast, echoes a Florida coast from long before the tourism era and includes Wakulla, Franklin and Gulf Counties. It has changed and grown over the years, and many of our favorite dining spots are only memories now. Julia Mae's Town

Mrs. Al Whitfield testing her pie for doneness, Wewahitchka, 1960. *Photography Jim Stokes.*

Inn, southwest of Sopchoppy in Carrabelle, was noted for its pie. I remember the anticipation of dining more than I remember the experience, but I do recall delicious chocolate, coconut and lemon pies. Luckily, there are a few new places that have filled the void left by Julia Mae's.

Apalachicola Chocolates offers more than chocolate candy and gelato. Its baked goods and pies are made fresh daily in the store on Market Street. With a baby on the way, Chef Kirk Lynch recently took over the business when he decided he needed to settle down. After working from Tampa to the Caribbean, Lynch found Apalachicola offered what he wanted. The biscotti, Greek wedding cookies, coconut macaroons and cinnamons rolls were fresh and delicious, but the display case of seasonal pies and daily offerings was the highlight, especially the whipped cream topped pumpkin spice pie. Across the street is a historic restaurant, the Apalachicola Seafood Grill, open since 1908 and serving a variety of seasonal cheesecakes and other desserts. Its strawberry shortcake cheesecake takes the common shortcake to a new culinary level.

Remotely located in Crawfordville at the southern end of County Road 365, the Spring Creek Restaurant has built a reputation for fresh food and great pies. Surrounded by the St. Marks National Wildlife Refuge on three sides and the Gulf of Mexico on the other, it is truly a special place in the Panhandle. With the coziness of walking into someone's home, Leo and his son Ben Lovel made us feel like one of the family. The restaurant opened in 1962, but the Lovels have owned it since 1977. According to our waitress, Dianne Carver, the pies have been made by Miss Lillian Miller for years. As we were sitting beneath a colorful drawing of Leo's mother, he told us how he and his two sons, Clay and Ben, keep the old traditional recipes going through the cooking process at the restaurant. They use an old-fashioned, time-honored slow cooking method to produce the thick pudding and slowly stir for even blending and flavorful fillings. Everyone's favorite seems to be the Key lime pie now, but Clay pointed out that if you're a coconut lover, the coconut cream is the one to choose. It's hard to resist chocolate peanut butter pie, so Jack and I tried all three. This family is charming and talented, and you can read about some of their escapades in *Spring Creek Chronicles*, written by Leo, illustrated by Clay and edited by Ben.

PS from Pat

In the mid-'60s, I watched the only TV station available, channel 7, and they ran a show called Cartoon-a-Rama for an hour prior to the evening news. It was sort of like The Howdy Doody Show *but better because it would have local kids as audience members to speak on TV and show cartoons. When I was lucky enough to be on the show once with my siblings, the show's host would go around the room asking kids how old they were and*

where they were from. When he got to our family, three of us provided our street address. "I am Pat from Parker and I am six years old" is what the host was attempting to get kids to say on live TV. I ain't for sure, but I think when he stuck the microphone in front of me, I froze up. Not sure what he expected from a five-year-old on the "best show in the world." Especially a show that has a commercial offering a free "All American" from McDonald's on your birthday.

Having only been to McDonald's once, I knew I liked the milkshakes. So I wrote a letter to McDonald's, according to the TV commercial's instructions, and gave my name, age and address so they would send me the gift certificate for a hamburger, golden French fries and a triple thick milkshake. It was all free! I got the certificate about two or three weeks prior to my sixth birthday. The family got all dressed up like we were going to church and then headed off to what I thought was going to be a trip to McDonald's. During the drive downtown, my dad asked me, with the entire family in the car, since my birthday was also the same day as my parents' anniversary, "Would be okay to go to Captain Anderson's Restaurant instead?" Pandemonium erupted in the back seat of the 1965 Plymouth. Three of the four kids were hootin' and hollering about going out to a real restaurant. Captain Anderson's was about as fancy of a restaurant as there was in Panama City, one of those restaurants that wins all the silver- or gold-spoon type awards. The type of place that my parents probably were embarrassed to take a child like me to because I didn't know how to act right at home, much less out in public. I was pretty upset and opposed the idea of going to anything other than McDonald's. My opposition was 100 percent due to me wanting a milkshake. (As much as I tried, my good sister and I always failed at our attempts at homemade milkshakes.)

Dad said that since I was the birthday boy, it was my decision. After all, it was my birthday, and I wanted a milkshake. I stuck with McDonald's. Then Dad promised to take me, and only me, to McDonald's another time. Under immense sibling pressure and my mom talking about how she wanted some of that "world-famous" feud cake, I agreed to go to Captain Anderson's. I can't remember the meal so much, but I do remember having a taste of feud cake. It was no McDonald's milkshake. Basically, the cake is not too sweet and full of pecans—not what a six-year-old boy hoping for a milkshake would even admit to liking. Fast-forward about twenty years, when I tried it again with my gorgeous wife. When my beautiful wife said, "This tastes good," this time I wasn't disappointed when I took a bite.

Chapter 4

Prelude to a Pie

The Sunshine State has an abundance of pies, but the king of them all is the Key lime. You will find it served in homes and restaurants and sold at bakeries and grocery stores. Before the Key lime pie was crowned the state pie of Florida in 2006, a great debate took place. Well, perhaps not that great, as they gave up when the legislative session ended in 1994. Sweet potatoes, strawberries and pecans were vying for the title, without a mention of peaches, peanuts or kumquats. Strawberry pie is beautiful and luscious and a reminder in Florida that spring is on its way. Sweet potato pie is almost heaven in a slice, and if you've never tried it, the recipe is simple—as easy as making a pumpkin pie. It is a Thanksgiving staple at our house.

North Florida is laced with pecan trees and is as different from the rest of the state as Key limes are to pecans. Taking a bite of pecan pie reminds me of North Florida, but a bite of Key lime pie is like sunshine in your mouth. Having grown up in the Panhandle, with pecan pie served at every family reunion, church dinner or special celebration, it still felt right for the Key lime pie to be chosen as the state pie. It is a pie that truly reflects the Sunshine State in spite of its dull yellow color. It is a pie with a history and a mystery surrounding its origins. Easy to make, it only seems daunting to those who taste it and think they could never re-create it in their own homes. But it is one of the easiest pies to make, and there are about 100,000 recipes out there claiming to be the original recipe or the best.

My recipe for Flamingo Pink Lime Pie in *Easy Breezy Florida Cooking* requires baking the pie for fifteen minutes, as many Key lime pie recipes

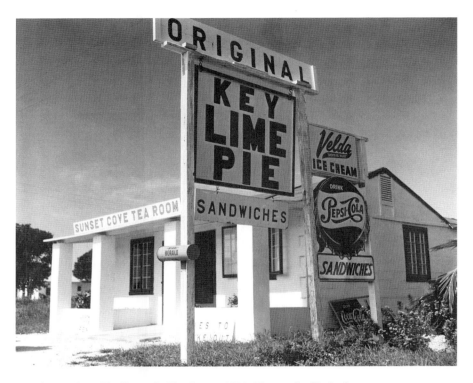

The Sunset Cove Tea Room in Key Largo, 1952. *Photography Charles Barron.*

call for today. I use Key limes but add a few drops of red food coloring so it changes from the dull yellow to a prettier pink. My niece DeLyn Sheffield McBride moved out west and substituted the limequats she found in her yard, using my basic recipe, and enjoyed successful results.

Flamingo Pink Lime Pie

1½ cups graham cracker crumbs
¼ cup butter, melted
3 ounces cream cheese, softened
1 14-ounce sweetened condensed milk
1 large egg
½ cup Key lime juice
3–4 drops red food coloring

Preheat oven to 325 degrees.

Mix crumbs and butter together; press firmly into a 9-inch pie pan.

Refrigerate crust while making filling.

In medium bowl, beat cream cheese with an electric mixer until smooth and creamy.

Beat in milk, egg and lime juice.

Stir in food coloring.

Pour into prepared crust and spread evenly.

Bake about 15 minutes.

Cool and refrigerate until well chilled, about 2 hours.

About four years after the publication of the *Florida Tropical Cook Book*, the Key West Woman's Club was founded in 1915. This century-old club published the handwritten *Key West Cook Book* in 1949, and the first published recipe for Key lime pie might be found in the book among the dozen pie recipes. One recipe calls for eggs, condensed milk and lime juice while another calls for gelatin. With instruction for putting the pie in the icebox, one might appreciate the modern versions found today. One recipe must have been adapted from a lemon pie recipe since the handwritten directions refer to the thick "lemon" mixture created from lime juice. In 1954, *The Second Ford Treasury of Favorite Recipes from Famous Eating Places* featured a recipe for Key lime pie from the now long-gone Tradewinds Restaurant in Key West. The recipe called for the three simple ingredients of condensed milk, eggs and fresh Key lime juice all cooked in a graham cracker crust.

In 1972, Lowis Carlton, former food editor of the *Miami Herald* and Florida Department of Agriculture food editor, as well as *Palm Beach Life* magazine, wrote *Famous Florida Recipes: 300 Years of Good Eating*, which included a recipe for the "Original Key Lime Pie," baked in a pastry or crumb pie shell and then topped with a meringue and baked until the meringue is "pale honey-colored." Although Key limes are no longer commercially produced in Florida, they are still found in home gardens, landscapes and area markets. Native to Southeast Asia, Key limes were most likely introduced to Florida during Spanish explorations by way of the West Indies. As difficult as it is to find fresh Key limes in the Keys today, the ubiquitous Key lime pie has spawned legends and stories and is popular not only in Florida but is on menus all across the country.

No one can say for sure when the very first Key lime pie was made, but one theory puts it in the late 1800s with Miss Sally, a cook for an early Key West millionaire, William Curry. She used her culinary knowhow to create a

dessert using a lemon pie recipe as a guide. Or did she get the idea from the sponge divers long at sea, with a list of rations including crackers for a crust, eggs, sweetened condensed milk and Key limes for the filling? Most likely a combination of the two led to the early popularity of Key lime pie. The high acid content in the Key lime helps to "cook" the yolks in a classic yet nontraditional manner through chemical reactions that change the texture of the yolk. This would work well while at sea, without any heat for cooking the custard-like filling. Canned milk eliminated the need for refrigeration or ice on the boat. Graham crackers, created by Sylvester Graham in the 1880s, are commonly used today for the crust, but crushed soda crackers or any cracker on board may have been used for the crust in the pie made on the open waters. Rolling out a pie crust, whipping up a meringue topping and baking the pie would most likely occur in a home kitchen. With Miss Sally's knowledge of cooking, she could have heard about the combination from the sponge divers or just tinkered with pie recipes to develop the famous Key lime pie. But one thing is for sure: it is the unique combination of egg yolk, sweetened condensed milk and Key lime juice that has the culinary lock on one of the most perfect sweets in Florida, possibly the most popular authentic American dessert.

By the 1970s, fresh Key limes were rarely found outside the yards of South Floridians, so the gelatin-laced, bright green globs of goo advertised as Key lime pie on the long drive from Miami to Key West gave the dish a bad name. When Floribbean cooking became popular in the 1980s, the authentic Key lime was reintroduced. In *Craig Claiborne's Southern Cooking*, Claiborne simply states, "If I were asked to name the greatest of all regional American desserts, my answer might very well be Key lime pie." He goes on to explain that it is the genuine Key lime juice that makes this simple pie so special. The Key Lime Festival celebrates the Keys and the birthplace of the Key lime pie, not to be mistaken with the Key Lime Pie Festival in Port Canaveral. Now the debate is whether to use a pastry crust or graham crackers and whether to top it off with a sweetened egg-white meringue, whipped cream or just leave it topless. You can find them all as you travel throughout the Keys and even the rest of the state. In a cup or a coconut, frozen on a stick or in a martini glass, with recipes ranging from the oldest to a secret or to grandmother's, Floridians and tourists are getting a taste of Florida with a bite of Key lime pie. Here is what Jack and I found on our drive from Key West to Miami. For the most part, they were all delicious. Jack proclaimed about ten times, "This is the best one ever." We only tasted a few that needed to be reworked.

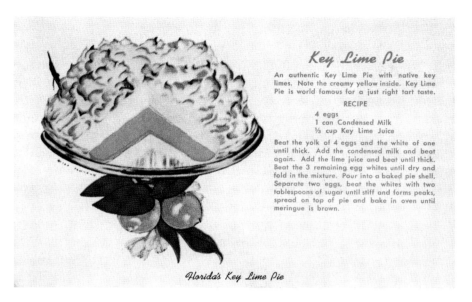

Key Lime Pie

An authentic Key Lime Pie with native key limes. Note the creamy yellow inside. Key Lime Pie is world famous for a just right tart taste.

RECIPE

4 eggs
1 can Condensed Milk
⅓ cup Key Lime Juice

Beat the yolk of 4 eggs and the white of one until thick. Add the condensed milk and beat again. Add the lime juice and beat until thick. Beat the 3 remaining egg whites until dry and fold in the mixture. Pour into a baked pie shell. Separate two eggs, beat the whites with two tablespoons of sugar until stiff and forms peaks, spread on top of pie and bake in oven until meringue is brown.

Florida's Key Lime Pie

Postcard of Florida's Key lime pie, with the recipe on the card, 1964. *Gulf Stream Card & Distributing Co.*

What seems to be the most popular place for all things Key lime in Key West is Kermit's Key West Key Lime Shoppe. Kermit was standing outside waving to the conch train with one hand and holding up his pie with the other as I crossed the street to enter his store. His warm and charming smile matches his personality. He shared with me how he has been creating these pies for twenty-five years, using his grandmother's original recipe. With two locations, one on Elizabeth Street and one on Duval Street, Kermit Carpenter serves Key lime pie whole, by the slice, frozen-on-a-stick dipped in Belgian chocolate or mixed with seasonal fruits or berries. And that's not all; once you step into his shop, it is like a wonderland of all things Key lime. They even have dog treats. Desirae Laguna was working the morning I stopped by and offered me a taste of the strawberry Key lime pie, and then she described the other seasonal Key lime combinations of blueberry, mango and pumpkin Key lime pie. There is so much to sample in the store that it made it hard to choose. If that is not enough, attached to the shop is Kermit's Kitchen Café, serving pancakes with Key lime syrup. Celebrating their twenty-fifth anniversary this year has not stopped them from consistently producing the most popular pie on the island.

Also in Key West, located on Greene Street, is the Key Lime Pie Bakery, where I tasted a coconut Key lime pie. Just down the road at the Key Lime Pie Company, I tried the parfait. For another taste, Jack and I had a Key lime tart for dessert at the Roof Top Café and a slice of pie at Blue Heaven—all a little different yet tasty in their own way.

When a famous French chef at a New York restaurant was commissioned to create a new dessert to celebrate the United States' purchase of Alaska, he called his creation Alaska-Florida, later to become Baked Alaska. Not to be outdone, the Key Lime Baked Alaska is on the menu of the fifty-year-old Islamorada restaurant Marker 88. Key Lime Baked Alaska, with a toasted marshmallow meringue swirled atop a rock-hard frozen Key lime pie, has been on the menu for decades. Other Islamorada pie stops included the Key Lime Pie Factory at mile marker 92 in Tavernier, which is a beautiful little place. The shop is filled with award-winning pies, cookies and slices of pie frozen-on-a-stick. At mile marker 74 is Ma's Fish Camp. This Islamorada restaurant is owned by Barbara Cockerham, who bakes her pies in small batches. Our server, Landon Pierog, moved to the Keys when he was five days old and never left. He charmed us with his stories but also served a delicious strawberry-laced Key lime pie. The combination was perfect.

Key Largo offered up three delicious Key lime pies, each unique. The Fish House restaurant, open for over twenty-five years at mile marker 102.4, served the pie in a graham cracker crust with a whipped meringue topping with perfect golden brown peaks. Mrs. Mac's Kitchen, open since 1976 with two locations in Key Largo, served an almost frozen version with whipped cream topping. And the Hobo Café, open since 1991 at mile marker 101.7, serves it by the slice or in a souvenir jar to take with you. In the jar, the filling is layered with graham cracker crumbs and topped with whipped cream. Then, on to Miami Beach, where Joe's Stone Crab restaurant has been famously serving Key lime pie as the perfect ending to a seafood dinner for generations.

Heading north to Davie, Florida, you will find Bob Roth's New River Groves. This kitchen table start-up company has been growing for over fifty years and now is home to Terry's Homemade Key Lime Pies, based on the matriarch's award-winning recipe. The mango Key lime pie is uniquely delicious and growing in popularity every year. Located on Griffin Road since 1964, the store is open every day from 8:00 a.m. to 5:00 p.m. What started out as a community of Florida citrus growers, packers and shippers based in South Florida now includes a fudge factory. There, Mila Chesney offers tastes of creamsicle orange, birthday cake and many other flavors of

Florida governor Bob Graham, in 1983, serving pieces of the World's Largest Key Lime Pie at the Conch Day celebration in Tallahassee. The seven-foot pie required 1,152 Key limes for its filling. *Photography Mark T. Foley.*

fudge. They also sell a variety of jelly, honey, juices, pies and more. Lisa Roth grew up in the family business and recalls a time when the entire family lived in the tiny apartment above the store and locals could "pick a peck" of fresh fruit for one dollar. Bob Roth's New River Groves is a place where you'll want to take your time, look around and enjoy a taste of Florida.

But the new player on the block, located in the bustling Wynwood Arts District, just north of downtown Miami, is called Fireman Derek's Bake Shop and Café. The once-abandoned warehouse neighborhood is now home to outdoor murals painted on the buildings, and the entrance to Fireman Derek's is a display of brightly colored bricks. Serving seasonal pies and other sweets, Derek Kaplan, along with partner Kim Murdock and son Patrick Murdock, have made their dream come true of owning a successful pie shop. When we stopped by, Kim and Derek were attending the New York City Wine and Food Festival along with their Key lime pie, which almost didn't make it through security. But Patrick, along with Brandon Quintana and K.C. Dolin, offered up their favorites. They all agreed the Key lime pie and crack pie are two of their most popular, but K.C. also likes the strawberry guava and Brandon likes the salty monkey. The crack pie, dusted with powdered sugar, reminded me of the butterscotch brownies I had forgotten about making for our son Jackson when he was growing up.

For pie by the slice or whole, other offerings included candy bar, chocolate peanut butter, berry, coconut custard, pecan, apple, s'mores, pear, pumpkin, blueberry, cherry, strawberry, lemon meringue and assorted cheesecakes.

From the Redneck Riviera to the Conch Republic—so many pies, so little time. But here is a sampling of what we found throughout the rest of the state. Just west of Lake Okeechobee, a locally famous pie establishment closed its doors a few years ago, just days after Jack and I finally made it to LaBelle. We were on our way to the Swamp Cabbage Festival and stopped by Flora and Ella's for lunch. Native Floridians and sisters Flora and Ella opened the restaurant in 1933, and Jack and I were sad to see the end of another old Florida restaurant but happy to have a taste of their famous pies. The good news is, we found where the pie maker from Flora and Ella's relocated. Christine now bakes and creates pies for the Farmer's Market Restaurant on Edison Avenue in Fort Myers, opened in 1952. Owner Bill Barnwell sold the restaurant to his son and daughter-in-law Chip and Betsy Barnwell in 2014. They carry on the tradition of a family-owned restaurant, with Betsy running the day-to-day operations. She beams with pride when talking about the pies that Christine creates with the assistance of Evelyn Goff. Our server, Melissa Wooten, helped Jack and me select the five best slices of the day: sweet potato, chocolate, peach, peanut butter and a local favorite, coconut.

On nearby Captiva Island, the colorful Bubble Room has long been noted for serving large slices of pies and cakes. On Sanibel Island, the Mucky Duck has its specialty, the Mucky Surprise, similar to a Mississippi Mud pie with a touch of espresso flavor. Jack and I discovered another restaurant, Traders Café and Gift Shop, on Sanibel along Periwinkle Way. We had Key lime pie and then enjoyed browsing the selection of Florida cookbooks in the gift shop.

From Amish pies to a Ritz surprise, Sarasota County offers places to unwind and relax in an upscale atmosphere or casual beach house. Staying at the Ritz Carlton Sarasota is a treat Jack and I reserve for special occasions. I convinced Jack that writing a book about Florida sweets is reason enough. We were both pleasantly surprised with the menu offerings for dessert at Jack Dusty's, the in-house restaurant. Our server, Efrain Vera, explained how every week the chef offers a weekend dessert special. But the standard fare on the menu was impressive enough, with a Cracker Jack®–like popcorn and peanut creation served in a cup. Even the house bread, baked in a can and served with rum butter, has a special sweet story. The recipe is on the cutting board underneath the slices of spicy warm bread. But it was their Key lime

ginger cheesecake that caught my attention because of the explanation on the menu: "Inspired by Jack Dusty's collaboration with students from the University of South Florida–Sarasota, Manatee Culinary Innovation Lab Summer Semester." Served with ginger cookies, the creamy Key lime cheesecake was laced with ginger snap streusel. Doughnut holes and s'mores milkshakes were also a part of the menu. We did not try everything, so I guess we will have to return for more research.

Yoder's, a Sarasota landmark in the Amish community of Pinecrest, has been baking and serving pies since 1975. It has grown to become Yoder's Restaurant and Amish Village, still serving Amish pies made from scratch. The pie menu changes with the season, but the day we were there, they offered a variety of cream pies: coconut, butterscotch, chocolate peanut butter and peanut butter. Cakes by Ron creates luscious-looking cupcakes that can be ordered off the menu or purchased in the gift shop at Phillippi Creek Oyster Bar in Sarasota. Also on the menu are Key lime pie and brownie à la mode with caramel. Our server, Doug Housley, told us the root beer floats are one of the most popular desserts served there.

We tasted a beautiful multicolored citrus cake from Hometown Desserts on Anna Maria Island. On Longboat Key, the chef-owned Euphemia Haye has an upstairs dessert room called the Haye Loft. The evening we arrived, the dessert counter was filled with a variety of pies: apple walnut with vanilla ice cream, southern pecan, peanut butter mousse, coconut custard, banana cream, Key lime and triple berry glaze. The casually elegant setting is also a comfortable location for a taste of bananas Foster, cherries jubilee and crepes Suzette, served flambéed.

Bradenton has a special restaurant known for its delicious pies since 1981, Miller's Dutch Kitchen. It has been a family favorite since Jack did a TV restaurant review there in the '90s and came home with a few of their pies. They sell thousands of pies during the holiday season, but year-round, the peanut butter pie is the most requested. Victor Davis, the manager, was kind enough to share the variety of pies served: banana, peanut butter, Key lime, coconut cream, chocolate, chocolate peanut butter and seasonal pies including peach, blueberry, blackberry, pecan, pumpkin, raspberry and strawberry. But that's not all to satisfy your sweet tooth. They also have homemade ice cream, bread pudding, cakes, sweet rolls and the Amish classic Erma's cakelike shoofly pie.

In Dunnellon, on North Florida Avenue (U.S. Highway 41), is the Front Porch Restaurant and Pie Shop, open since 1986 and owned by Stan and Mary Scally. The lemon meringue pie is the most popular with its soaring

peaks of toasted meringue. Stumpknockers, on the square in historic downtown Inverness and with another location on the Withlacoochee River in Dunnellon, offers a popular peanut butter pie. Amy Brill, our waitress, served us a slice of this fluffy delight, loaded with chocolate and whipped cream. The Yearling restaurant, just south of Micanopy and Cross Creek on County Road 325 in Hawthorne, gives a taste of old Florida with its sour orange pie, which is a family favorite of Florida native Peggy Macdonald of the Mathison Museum in Gainesville.

Pie Heaven Bakery Café is located just north of Jacksonville Beach at Atlantic Beach. Anita Hyde, the owner, and her friend Linda Holfinger opened the shop after "long conversations with God." She turned to pie making after she was laid off from the insurance business. Made from scratch each day, there are big pies, little pies, savory pies, sweet pies, whole pies and slices of pie to eat in or take out. Jack and I had a slice each of the country chocolate and the raspberry pie. But Anita told me the strawberry pie is the most popular.

In South Tampa is the world-famous Bern's Steak House. Jack and I went with friends so we could taste a variety of the more than fifty desserts offered in the private Harry Waugh Dessert Room on the second floor. We tried the following: Banana Cheese pie, a Banana Cream Cheese mousse

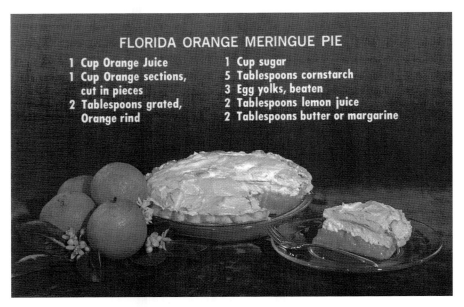

Postcard with a recipe for Florida orange meringue pie. *Southern Card and Novelty, Inc.*

in an almond praline crust; a Trio of Liquid Center cakes; Brown Sugar, a selection of three sweets; the Granny Smith apple pie served with cinnamon ice cream; and the Macadamia Decadence cake. Jack recalled the time Bern Laxer took him on a tour of the soon-to-be dessert room and how excited Laxer was about another new adventure in dining. With worldwide fame, it is a dessert mecca.

Another Tampa favorite is the stylish yet relaxed Ava. Owners and good friends Michael Stewart and Joe Maddon, the previous Tampa Bay Rays and now Chicago Cubs manager, opened Ava across the street from Stewart's 717 restaurant. When Jack and I asked Stewart what his favorite dessert was, he said, "Wait just a minute, I'll show you." He brought out rosemary cookies that are featured on the menu with a caramel dessert. Those cookies, along with the Caramel Budino, the house-made gelato, the seasonal peach melba and more, make us thankful Ava is in South Tampa.

A chapter on pies would not be complete without mentioning the success story of Mike Martin. A South Tampa resident, he starting out making pies for friends as gifts and now has a state-of-the-art thirty-thousand-square-foot facility putting out pies for businesses and restaurants across the country. You can read more about him on his website, mikespies.com. If you see Mike's Pies on a menu or in a store, you can count on a slice of heaven.

PS from Pat

My wife, Carolyn (Castles Sheffield), makes my favorite dessert, Florida carrot cake, using carrots from my garden. My second favorite is Florida lemon pie. Growing up, my mom and good sister didn't make a lot of lemon meringue pies, but I always got to eat them at the Sheffield and Owens family reunions. Now, my gorgeous wife and trusty daughter make wonderful lemon pies every winter from my stock of home-grown lemons. I have even squeezed the juice and frozen it for use throughout the year. Tied for third are citrus pie and pecan pie. Carolyn uses fresh pecans from her parents' North Florida farm, and these pies that she makes remind me of the ones I had growing up. Carolyn's Florida citrus pie, using fresh home-grown Key limes and blood oranges, is a great pleasure to eat around Christmas and New Year's each year. There is nothing as good as watching an FSU bowl game victory and eating citrus pie.

Carolyn mixes the juices from my potted Key limes with my yard-grown blood oranges and adds a touch of cold whoop to make a mild citrus pie. I've got to keep the limes in a pot so I can bring them in the shed on those few freezing nights we have in the Panhandle each year.*

Carolyn's Tasty Florida Citrus Pie

5 egg yolks, beaten
1 14-ounce can of sweetened condensed milk
¼ cup Key lime juice from Pat's tree
⅓ cup of blood orange from Pat's tree
*½ cup of cold whoop**
9-inch graham cracker pie crust
can of Reddi Wip
zest of lime and orange for garnish

Preheat oven to 375.

Combine and mix egg yolks, milk, juices and cold whoop.*

Pour into unbaked graham cracker shell.

Bake 20 minutes. Let cool (in refrigerator if husband is getting impatient and ready to eat). Top with Reddi Wip and garnish.

Serve to husband with smile.

Stand by for much appreciation and love in return for serving such a tasty Florida pie to husband.

(I did take some husbandly liberties by adding/altering her directions a tiny bit.)

*The package spelling is Cool Whip.

Chapter 5

Sugar, Spice and Sweets to Entice

During Florida's plantation period, from 1763 to 1865, sugar was one of the thriving industries, if short-lived. Establishing sugar plantations along waterways and taking advantage of Florida's soil and climate gave plantation owners hope of a successful business. Many of the ruins today are preserved as parks showing the inner workings of processing the cane and shipping products along waterways. The Turnbull and Kingsley plantations in northeast Florida were two of the early ones. Historic Dunlawton Sugar Mill Gardens in Port Orange was home to one of the first successful mills in the state. It started with a land grant in 1804, and by 1832, it was known as the Dunlawton Plantation, producing sugar and molasses until 1835. It was burned down and abandoned in 1846 and then rebuilt and productive until 1853. It burned down again in 1856, and by the 1940s, it had been resurrected as an amusement park for east central Florida called Bongoland, featuring stone dinosaurs, an Indian village and a train ride. Today, ruins of the sugar mill and amusement park are an eclectic setting for the botanical gardens.

Yulee Sugar Mill Ruins Historic State Park, in Homosassa near Crystal River on the west central coast, was once part of a thriving sugar plantation built by David Levy Yulee. A member of Florida's first constitutional convention and territorial delegate to Congress, Yulee later became Florida's first senator. The Civil War brought destruction to most of the sugar plantations in Florida, and Yulee's Margarita home was burned by Union forces, after which the sugar mill fell into ruin. You

Sugar Cane Crusher, Lost Mission and Olde English Sugar Mill

3 Miles South of Daytona Beach at Port Orange, Florida

Postcard featuring the machinery at the Dunlawton Plantation Sugar Mill Ruins in Port Orange, postmarked 1949. *Colourpicture.*

can see the ruins of the boiler, chimney, kettles and other machinery as the park is being restored to further showcase the history of Florida. The Gamble Plantation Historic State Park, in Ellenton, in southwest Florida along the Manatee River, is home to the only surviving antebellum sugar plantation mansion in South Florida. The nineteenth-century Florida frontier sugar plantation produced up to 1,500 barrels of sugar yearly between 1843 and 1859, reported Major Robert Gamble Jr.

Many of the smaller sugar farmers depended on sugar mills to grind their cane for them. Huge broad-brimmed iron kettles were filled with the juice from the cane crushers for boiling into syrup. Most cracker homesteads had sweet potato and sugar cane patches in their fields or gardens. Sweet potatoes became a staple food for Florida crackers, and sugar cane could be processed into syrup for personal use or sold for extra income. Hoecakes and cane syrup were often the only dessert at these simple cracker tables.

Cane syrup was a staple in Florida households, and community cane-grinding celebrations were part of these homesteaders' highlights. They would combine resources in the fall and ease the burden by sharing the

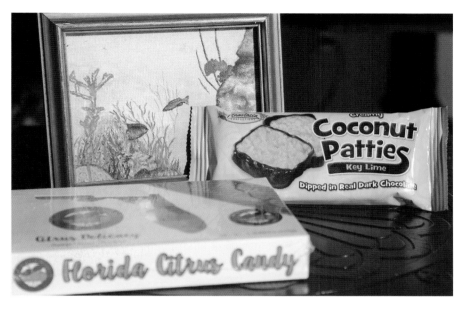

Above: Sweet treats from Davidson of Dundee and Anastasia Confections.

Below: Pat Sheffield showing Key limes from his tree in Panama City.

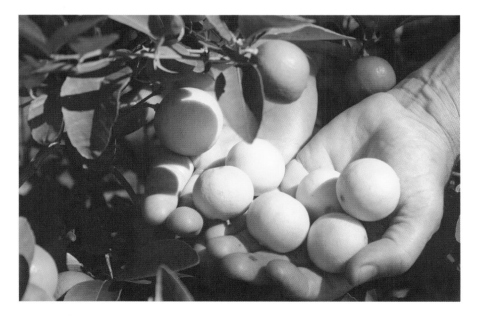

Left: Lisa Roth holding a mango Key lime pie at Bob Roth's New River Groves, Davie.

Below: Desserts of the day offered at Sweet Magnolias in Millville, near Panama City.

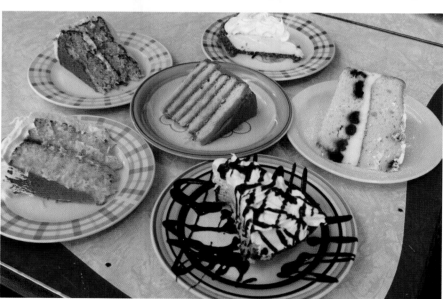

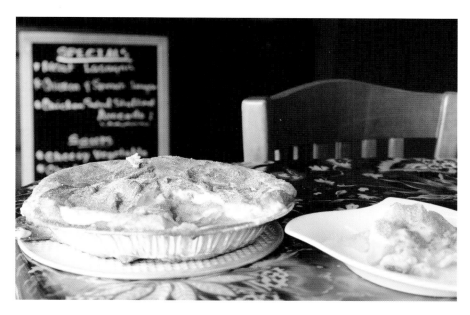

Peaches and cream pie, Sugar Mill Sweets, Fort Walton Beach.

Coconut pie, Key lime pie and chocolate pie, Spring Creek Restaurant, Crawfordville.

Top five pies slices at Fireman's Derek's Bake Shop and Café, Miami.

Popular pies served at Farmer's Market Restaurant, Fort Myers.

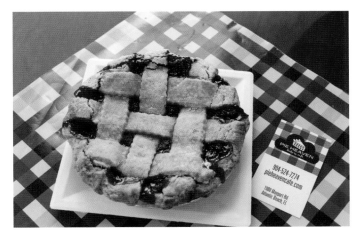

Lattice-topped berry pie, Pie Heaven Bakery Café, Atlantic Beach.

Carolyn's Tasty Florida Citrus pie. *Courtesy of Pat Sheffield.*

Key lime pie in a jar, Hobo Café, Key Largo.

Kermit Carpenter outside his store, Kermit's Key West Lime Shoppe, Key West.

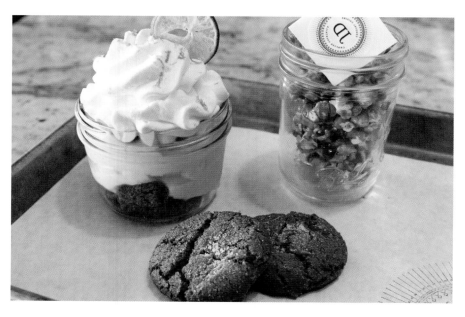

Key lime ginger cheesecake, Jack Dusty's, Ritz Carlton, Sarasota.

Homemade jelly for sale, Desert Inn, Yeehaw Junction.

Mattie Acklin, Tara Acklin and Mary Barnett, Royal Scoop, Bonita Springs.

Banana split,
Andy's Igloo,
Winter Haven.

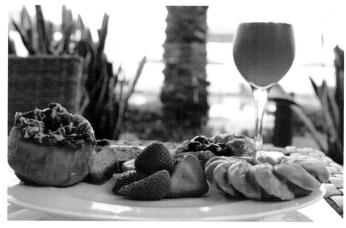

Pastries and juice
for breakfast by
the beach, The
Breakers, Palm
Beach.

Flip-flop cookies,
Chez Bon Bon,
Fontainebleau
Hotel, Miami
Beach.

Emilee Leisten, Zeno's Boardwalk Sweet Shop, Madeira Beach.

Candy Vasconcellos preparing chocolate at Peterbrooke, Palm Beach.

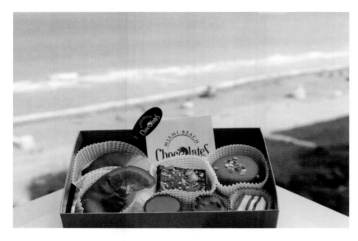

Miami Beach Chocolates, Miami Beach.

Gelato and chocolate, Oh My Chocolates, West Palm Beach.

Norman Love Confections, Estero.

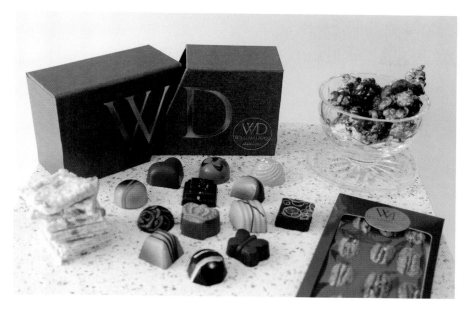

William Dean Chocolates, Tampa.

Wes Mullins, William Dean Chocolates, Belleair Bluffs.

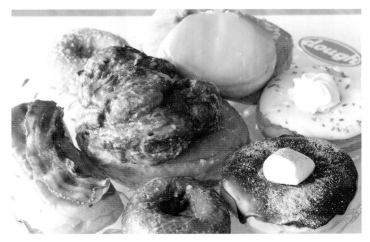

Dough doughnuts and more, Tampa.

Bee-Sting Yeast Cake, Yahala Bakery, located east of Okahumpka and west of Howey-in-the Hills.

Sweets from Le Petit Sweet, Mount Dora.

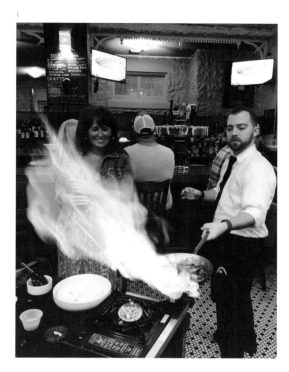

Waiter Zack Endrias preparing
Plantains Foster for Karen
Romeo, Mount Dora.

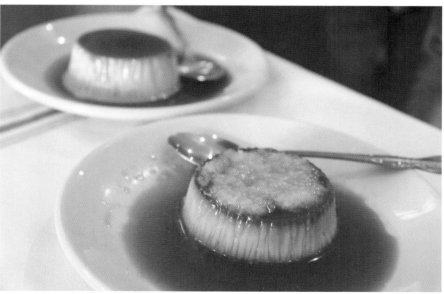

Coconut and plain flan, Little Havana, Miami.

Robert-Is-Here, and so was Jack, checking out the sugar cane, Homestead.

Tangerine marmalade from Davidson of Dundee.

Kermit's Key lime and strawberry Key lime pies.

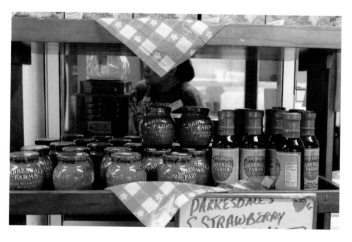

Strawberry jelly from Parkesdale Farm Market.

Key lime cake balls from Key Largo Chocolates.

A slice of famous feud cake from Captain Anderson's Restaurant.

work and the resulting syrup. Today, we have the luxury of visiting living history museums where demonstrations are given to show how syrup making was done during the early pioneer days. Dade City Pioneer Museum and Village features a cane syrup mill, and Dudley Farm holds an Annual Cane Day. The first Saturday in December, there is a Long Cane Syrup Day in Two Egg. Jack and I were driving through the area on the eve of Cane Syrup Day and saw a soft, warm light glowing under a shed in the distance as preparations were being made for the next day.

The modern sugar industry began in 1928, along with the United States Sugar Corporation in Clewiston, located along the south side of Lake Okeechobee. The swamp became the sugar bowl of the country. Sugar cane was harvested in the Everglades by cane cutters and made ready for loading and hauling in field wagons to railroad cars that transported it to the sugar house in Clewiston. Mills set up near the cane fields crushed the cane, and then the liquid was condensed and crystallized into raw sugar. Today it is the world's largest fully integrated cane sugar milling and refining operation, filling bags and boxcars with sugar.

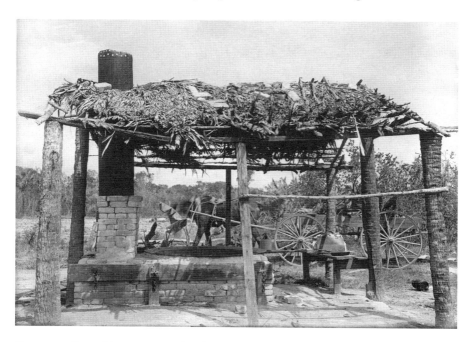

Evaporator for making cane syrup in 1916 at a clearing in Snake Hammock, Monroe County. *Photography John Kunkel Small.*

Traveling along Sugarland Highway, as you enter Clewiston, a sign welcomes you to "America's Sweetest Town." The Clewiston Sugar Festival was revived in 1986 to celebrate the original tradition of the end of the sugar cane harvest when the last carload of cane was ground for the season. A barbecue was held for the workers and their families, and a dance commenced in the Sugarland Auditorium, culminating with the crowing of a king and queen of sugar. Now this multi-day event is open to the public and features live entertainment and cane-grinding demonstrations. Food booths and a car show are not overshadowed by the rodeo and the bass tournament, along with Seminole Heritage Day at the Clewiston Museum.

The combination of sugar and spice helps to create some of the most basic desserts not only in Florida but around the world. Spices were special, wrote Tom Standage in *An Edible History of Humanity*, and "provided an otherworldly taste of paradise amid the sordid reality of earthly existence, which in turn inspired the first circumnavigations of the earth." European explorers came to the Americas in search of spices along with gold and other treasures, and *La Florida* was discovered. Spice cakes or gingerbread date back to before the Middle Ages. The gnarled and knobby tough-skinned root of ginger, with its peppery-spicy-sweet taste, is what gives such a distinctive flavor to one of the most historic and popular desserts in the world: gingerbread.

At one time, gingerbread was made of stale bread, with added spices and sweeteners for flavor. According to Maguelonne Toussaint-Samat in *A History of Food*, written in 2009, honey was the original sweetener. During the Restoration Period of the 1660s, molasses, a byproduct of sugar production and cheaper than refined sugar, replaced honey. The roots of sugar growing in Florida began with Spanish exploration, and it continues to be cultivated today. A major crop for plantations during the antebellum era, wild orange groves were replaced with sugar cane fields. Once sugar cane was introduced, honey wasn't as valuable. Sugar and spice has long been a natural combination, and the legacy of spice cake is a long one. Following the path of gingerbread may help explain the metamorphosis of cooking today. One of the first desserts, whether served as a cookie or a cake, it is still a popular treat. While the cake or gingerbread is made with dried ginger and other spices to create a usually dark and moist cake, baked with molasses, the cookie is crisp and thin and oftentimes cut in the shape of a little man.

Martha Washington's Booke of Cookery and Booke of Sweetmeats, from 1749, features a recipe for pepper cakes, using ginger as the pepper.

Her recipe "To Make Ginger Bread" calls for half a pound of ginger. Amelia Simmons used pearl ash for making gingerbread and introduced this new leavening agent to North America in her cookbook *American Cookery* in 1796. Saleratus, a precursor to baking soda and more powerful than pearl ash, is a term found in cookbooks used before baking soda became a common household ingredient. Other leavening agents used before baking soda and baking powder were on the market were eggs and yeast. Simmons's recipe for "Gingerbread Cakes, or butter and sugar Gingerbread" calls for three pounds of flour, a grated nutmeg, two ounces of ginger, one pound of sugar, three small spoons of pearl ash dissolved in milk, one pound of butter and four eggs. After the ingredients were combined, it was to be kneaded stiff and shaped before baking for fifteen minutes.

In 1824, Mary Randolph in her cookbook *The Virginia Housewife or, Methodical Cook* provided three gingerbread recipes: one without leavening, one with pearl ash and one with frothy eggs. Her recipe for "Plebeian Ginger Bread" calls for three large spoonfuls of pounded ginger, three quarts of flour, three teaspoons of pearl ash dissolved in a cup of water, half a pound of melted butter and a quart of molasses. The instructions are to mix, knead well, cut in shapes and bake. Pounded ginger was not as strong as the ground ginger found on grocery store shelves today.

What Mrs. Fisher Knows about Old Southern Cooking, published in 1881 by Abby Fisher, includes 160 recipes and is the first cookbook written by a former slave. She includes two gingerbread recipes: "Old-Time Ginger Cake," leavened with soda and eggs, and "Ginger Cookies," which requires yeast powder. Teacups were used as measuring utensils and baking instructions were brief, such as "bake in oblong pans" and "bake as you would a biscuit." She also uses a combination of butter and lard for her cookies.

Then came Fannie Merritt Farmer, who wrote *The Boston Cooking-School Cook Book* and laid the foundation for proper recipe writing. Influenced by Ellen Richards (the first woman to graduate from MIT while studying foods and nutrition, along with home economics), Farmer's 1896 cookbook became a model for new American cookbooks. She introduced the standardization of written recipes with step-by-step instructions and recommended cooking temperatures and times. The eighth edition, published in 1948, includes a chapter on gingerbreads and doughnuts. She states, "Gingerbreads vary from the simplest eggless mixture made with hot water to a rich and buttery sour cream recipe, which makes no

pretense of being inexpensive." Those recipes are included in her book, along with a recipe for soft molasses gingerbread. Rather than include butter or shortening in that recipe, she lets the baker make that decision. She goes on to explain that as a dessert, it should be cut in squares and served with whipped cream.

Southern Cooking, published in 1941 by S.R. Dull, explains in part in the foreword of her book why she wrote it: "The interest taken in my weekly page, in the magazine section of the *Atlanta Journal*, which I edited for twenty years, convinced me of the need for an authoritative source of information on the preparation of foodstuffs 'the Southern way,' and as a consequence 'Southern Cooking' was born in 1928." She includes recipes for gingersnaps, ginger cakes and gingerbread, including one called "1850 Ginger Cakes" using syrup and lard. She gives the reader the option of using butter or lard or a combination of both and then goes on to say peanut butter or bacon drippings can be used as a substitute. One recipe lists the ingredients with the only instructions, "Bake in moderate oven."

Marjorie Kinnan Rawlings, author of *The Yearling* and *Cross Creek*, shared stories, menus and recipes in her book *Cross Creek Cookery*, where you catch

Cross Creek Cookery on display at the home of Marjorie Kinnan Rawlings. *Author's personal collection.*

a glimpse into her rural Central Florida life during the 1930s and '40s. She explains why she wrote if not the most, one of the most, popular Florida cookbooks: "It would be inaccurate to say that I assembled this *Cross Creek Cookery* in response to widespread popular demand. I need only the slightest interest and curiosity to give me an excuse to pass on my better dishes." Rawlings includes one recipe for gingersnaps and one recipe for Evadne's gingerbread. She followed her own format in recipe writing by including extra ingredients in the instructions, along with personal comments. On desserts, she said, "company seldom refuses dessert, and I have been known to invite ten for dinner just because I was in the notion to make cake." Rawlings studied Fanny Farmer's cookbook but found the new foods in Florida a challenge, yet still proclaiming in part, "Some of my best dishes are entirely native and local." It is in her chapter on desserts that she shares the most recipes, some of which she learned while watching her mother bake as she was growing up and later regretted she didn't write down the instructions for her favorites.

Listed in the National Registry of Historic Places, her homestead, an orange grove, farmyard and cracker house, is now the Marjorie Kinnan Rawlings Historic State Park. Over seventy-five years ago, she found solace in rural Florida and described the land as enchanted, even as she found her dwelling, in a seventy-two-acre orange grove at Cross Creek, shabby. After writing the Pulitzer Prize–winning classic Florida novel *The Yearling*, she purchased a house in Crescent Beach, just south of Jacksonville, and there she wrote *Cross Creek* with the accompanying *Cross Creek Cookery*. Rawlings's grove included a variety of oranges such as navel, Parson Brown, Blood, Trifoliata and other citrus, including grapefruit, tangerines, lemons and kumquats. From appetizer to dessert, citrus was celebrated in *Cross Creek Cookery.* While serving mango ice cream to her summer visitors, baked sherried grapefruit and tangerine sherbet were a part of her first Christmas in 1928 at Cross Creek. Rawlings described the sherbet as extremely exotic tasting with a gorgeous color yet very simple to make; "the only tricks to it are in having one's own tangerine trees—and the patience to squeeze the juice from at least a twelve-quart water bucket of tangerines." Regular oranges were too sweet, so Spanish Seville were used for Scotch and English marmalades. She was pleasantly surprised to find her own Seville orange tree on the property and finally had the key to perfecting homemade Scotch marmalade.

Rawlings wasn't the first author to find solace in rural Florida. Long before the 1860s Homestead Act, when pioneers flowed in to the Florida

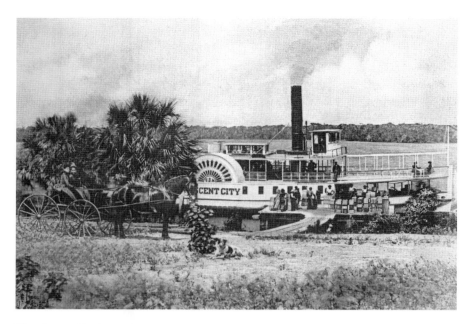

The *Crescent City* day boat carrying passengers and oranges at San Mateo in 1890. *Creator Adolph Wittemann.*

frontier, stories of Florida's alluring landscape and natural resources were recounted by others. Citrus groves seemed to be a major theme for most of these writers, accented by the beauty of the state and the sweetness of the edibles found growing in abundance.

The essence of Florida was in part its natural resources providing fodder for glowing descriptions by some of these early authors, which gave Florida a boost in popularity as a tourist destination. Florida was more than orange groves and sunshine, as revealed by the acclaimed botanist William Bartram in his 1791 book *Travels and Other Writings*. There he chronicled what he saw and sometimes what he ate. His journey started in Palatka, heading south along the north-flowing St. John's River. Indians along the way provided "baskets of the choicest fruits," including peaches, figs and oranges. He writes of a watermelon feast that he found extraordinary. Being a hot and sultry late September day, the "cool, exhilarating fruit was still in high relish and estimation." Other sweet treats were enjoyed, such as a refreshing mix of honey and water to quench his thirst.

The precursor to the railroad age, the steamship era boomed for a short period. Starting in Jacksonville or St. Augustine, visitors and others

traveled the St. John's River, with stops at pioneer towns such as Palatka, Enterprise and Sanford. Daily service onboard side-wheel steamships offered views unattainable from the wilderness surrounding the charming and alluring river. They were served meals with desserts such as mince pie, pumpkin pie, ice cream, fruits and a variety of cakes. Less than a century after Bartram chronicled his travels, another poetic writer was enchanted with Florida and its orange groves. Harriet Beecher Stowe arrived at Mandarin, Florida, in the 1870s, about twenty years after the publication of her most recognizable work, *Uncle Tom's Cabin*. Her later book, *Palmetto Leaves*, describes the enchanting lifestyle along the St. John's River and within her orange grove. Stowe felt the orange tree best represented the "tree of life" with its clusters of oranges hanging from the branches bestowing beauty and grandeur like no other.

In addition to oranges, Stowe cultivated peaches, pears, strawberries, blackberries, blueberries, huckleberries, plums and bananas. She described everyday activities such as fishing, picnics and seasonal steamboat rides along the river with tourists. Eventually, oranges from her groves were being shipped north and advertised as "Oranges from Harriet Beecher Stowe, Mandarin, FLA." Preserving fruit and berries was common, and in response to a letter she received at her Mandarin home, she included a way of preserving figs. Stowe picked up the method from talking to the local residents in rural Florida. The process involved the use of lye to soften the figs before drying them in the sun. She was fascinated with cane grinding and sugar making and enjoyed excursions to watch the process. Tasting the amber-colored syrup from saucers led her to describe it as "liquid sugar candy."

After seeing Florida for the first time in the winter of 1879–80, George M. Barbour, a correspondent for the *Chicago Sun*, was so impressed that he was encouraged by friends to chronicle his excursions, which he did with *Florida for Tourists, Invalids, and Settlers*, published in 1882. Describing the tropical paradise laden with orange trees, mangoes and more, he included practical information concerning the climate and soil, farming and gardening, the cities and towns, resorts and sports along with descriptions of people, how they lived and the routes of travel he encountered. "It is a delightful place," and "transient winter visitors did not rightly appreciate all the delights of June in January." He goes on to say, "The largest peach-tree, undoubtedly, in America, is near Orange City, in Volusia County, with a spread of branches over seventy feet in diameter!"

Barbour divided the state into three regions: north, middle and south. The north temperate area contained sugar cane, apples, grapes, peaches and figs, with picturesque springs and streams nestled near rolling hills and grand forests. Middle Florida, with its semi-tropical climate, produced an abundance of orange, lemon, fig, guava, citron, grape and cane, with large lakes. Orange groves were home to thousands of trees being set out yearly. Barbour commented that watermelon and strawberries were rapidly becoming the leading crop or industry of the state. Tropical South Florida was a rich environment for pineapple, banana, coconut, guava, sugar-apple, bread-fruit, sugar cane, almond, fig and an innumerable list of tropical fruits. From Tampa Bay to Key West, "this is the region to go for purely tropical products and for the benefits of a summer climate in winter."

Barbour ate pineapples, peaches, figs, guavas, strawberries and bananas and enjoyed drinking the unique orange wine of the state. Wineries in Florida today seem to be around every bend, which is only natural since Florida was home to winemaking since the early Spanish exploration days thanks to muscadine wine. Muscadines were growing wild when Florida was first settled, and they have been cultivated for over four hundred years, as Native Americans were drying them when settlers first arrived. A renewed interest has brought back the sweet and musky-tasting muscadine for juice, wine, pie and jelly. Scuppernong is a type of muscadine and is popular in the South. We enjoyed picking them in the wild when visiting Granny Sheffield in North Florida.

PS from Pat

Two of my first memories of eating sweets were sugar cane and peanut brittle. In the 1960s, our family would skip church once a month and pile into our 1965 Plymouth for the hourlong drive toward the Florida-Alabama state line to visit my momma's family. My grandparents on my mother's side called each other "Trix" and "Auth" in a strong southern accent that's difficult to be described in writing. It wasn't until I was in college that I discovered that my Granny's name was actually Trixie and Grandpa's name was Arthur. In their early years, my grandparents on my mamma's side were basically sharecroppers. They didn't call it that; they just called it working in the fields. After my supposedly sophisticated education at FSU and hearing about and watching movies related to the poor sharecroppers in the South who were not able to pull themselves out of poverty, I realized that was my mom and dad's families. Amazing that the FSU campus

was less than a two-hour drive from where five generations of my family came from, but they didn't seem to understand or accurately depict them.

At my grandparents' home, during the summer and early fall, there were plenty of stalks of sugar cane lying around. Not the green type that a modern-day tourist might see when traveling off the beaten path or when a Yankee takes the scenic road on the drive home from Disney. We had the good chewing type cane that is rarely grown any longer called (blue) ribbon. Grandpa always cut the grandkids a section or two of cane. If he didn't, I knew where it was located and helped myself. I always had a pocketknife to cut the cane into manageable sections. Today, a father would probably go to jail for giving his eight-year-old son a pocketknife.

Chapter 6

Jelly by the Jarful

*W*alking through Cracker Country at the Florida State Fairgrounds or through Heritage Village in Pinellas Park, one becomes immersed in the experiences of the time and begins to get an idea of just how difficult it was when Florida was first being settled by pioneers, who were later referred to as crackers. With the help of Seminole Indians, descendants of various Creek tribes and their combination of knowledge, oftentimes they worked together to create staples that made the difference between survival or not. Once mason jars were introduced in 1902, canning was one of the most economical ways to preserve fruits and vegetables for yearlong treats, especially jellies, jams, marmalades and preserves. The natural bounty of the land provided Indian fig (prickly pear), sea grapes, cocoplum, arrowroot, muscadines or scuppernongs and guava. The journey from plant to plate is sometimes, if not long, a tedious one.

Home cooks have been preparing seasonal sweets since it was discovered that a combination of citrus, sweet fruit juices and heat produces a delicious-tasting spread that can be stored and enjoyed year-round. Cocoplums are usually found in South Florida as an ornamental shrub in parks and along roadsides, not in the pantry. The sweet-tasting prickly pear was a seasonal treat, pretty and pink, but harvesting was difficult because of the prickly glochids that had to be removed before eating. Sea grapes, a popular indigenous food growing wild along the shoreline, were easier to pluck from the bush but more time consuming to acquire enough to produce a jarful of jelly. Ripening one at a time among a dense cluster of green grapes, plucking

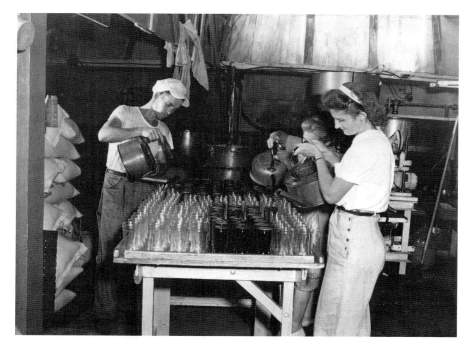

Employees at the Lone Palm Preserving Company in Bradenton filling guava jelly jars, 1949.

the deep purple ones out of the bunch had to be a labor of love or hunger for something sweet. More commonly found today on market shelves are guava jelly and orange marmalade, along with strawberry and blueberry preserves. The Palmetto Canning Company in Palmetto started producing guava jelly in the late 1920s, and at one time, it also made sea grape jelly.

Memories of figs in the fall and scuppernongs in late summer take me back to my childhood and family trips to northwest Florida to visit Granny Sheffield. A Florida cracker and part Seminole Indian, she put up what seemed like hundreds of jars of fig preserves. They were lined up in cupboards and on counters when we arrived. With daylight beaming in through her kitchen window and homemade curtains billowing in the breeze, the fig preserves were glistening in the sunshine, ready to be placed atop a hot buttery homemade biscuit. I don't know if it was the hand-churned butter or just Granny's magic touch, but I have never been able to re-create her delicious-tasting biscuits exactly. Her fig preserves were a little easier to master.

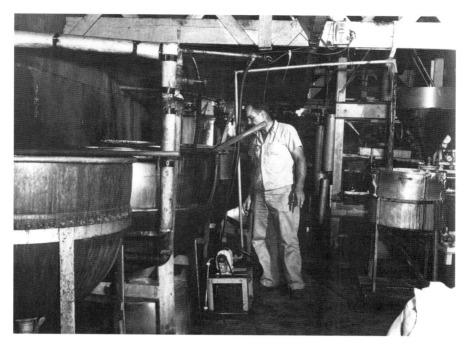

Guava jelly making at the Lone Palm Preserving Company in Bradenton, 1949.

Mattie's Fig Preserves

I quart fresh figs
3 cups sugar
2 cups water
I teaspoon lemon juice

Layer figs and sugar in a Dutch oven, add water and bring to a boil,
 stirring occasionally.
Reduce heat, stir in lemon juice and cook over medium heat 2 hours,
 stirring occasionally, until syrup thickens and figs are clear.
Serve with hot buttered biscuits.

In *Mrs. Hill's New Cook Book*, she suggests using "fruit when it is not quite ripe" soaked in weak, warm soda water to help remove the skin. The figs are then cooked in a sugar syrup before canning. This excerpt from *The Dixie Cook-Book* has another method for making fig preserves, according to ex-governor Sterns:

Gather fruit when fully ripe, but not cracked open; place in a perforated tin bucket or wire basket, and dip for a moment into a deep kettle of hot and moderately strong lye (some prefer letting them lie an hour in lime-water and afterwards drain); make a syrup in proportion of one pound sugar to one of fruit, and when the figs are well drained, put them in syrup and boil until well-cooked; remove, boil syrup down until there is just enough to cover fruit; put fruit back in syrup, let all boil, and seal up while hot in glass or porcelain jars.

If you are going to make or purchase preserves and jellies, you need a good biscuit upon which to place the tasty globs of fruity sweetness. A short history of the evolution of biscuits begins with the beaten biscuit. The laborious process of beating air into the dough by hand was one way to produce a leavened biscuit before baking soda and baking powder were commonplace. Beaten biscuits were considered an upper-class status symbol due to the excessive labor and time necessary to reach just the right texture to produce the perfect biscuit. Years after plantation life was over, Martha McCulloch-Williams refers to them as "Old Style" beaten biscuits in her 1913 cookbook, *Dishes and Beverages of the Old South*, as they were then considered old-fashioned and easily replaced by leavened biscuits.

Along with a beaten biscuit machine, the Industrial Revolution (1830–1920) brought many food-related labor-saving devices. New and improved commercially manufactured food products such as packaged yeast, milled wheat flour and baking powder were introduced. By the turn of the twentieth century, old-fashioned beaten biscuits and quick breads made with baking soda had been replaced with white bread as a status symbol in the home. Andrew F. Smith sums up in *American Food and Drink*: "Urbanization also created the concentration of potential customers that made the mass distribution of bread financially viable.... City dwellers were able to pay for the ease and convenience of buying baker's bread: and women's tasks shifted from making things to buying things."

Soda biscuits became popular with the ease of preparation due to leavening agents, making them a staple at every pioneer dining table. Served on the damask-covered dining table of the plantation or the humble cracker table in the kitchen, they were the perfect vehicle for homemade jellies and jams. At first, baking powder was considered dangerous for fear it could explode, but once it was widely accepted,

the southern biscuit was on the rise. Today we rely on expertise in the kitchen and knowledge of baking products. Take flour, for instance; since not all flour is alike, you need to use soft, low-gluten southern flour like White Lily to make great southern biscuits. Some all-purpose flours in the South are low in gluten because they are blended more for biscuits than for bread. Today, many options are available for biscuit making at home, but sometimes other factors affect the final product, such as oven temperature and outdoor humidity.

Granny Sheffield used self-rising flour to make her fluffy biscuits. As we drove down the dirt road on the way to her house, we knew once we arrived she would go into the kitchen, reach to the top of her pie safe and pull down a large oval wooden biscuit-making bowl already filled with flour. She would add just the right amount of lard and milk to make the best-tasting biscuits I ever put fig preserves on. The biscuits were shaped by hand, using no rolling pin or measuring cups, and served hot from the oven. She put the wooden bowl away with plenty of flour left for the next time. I never saw her add flour to the bowl, but she never seemed to run out. I can still remember her priming the water pump at the kitchen sink and the smell of her Cashmere Bouquet soap at the back porch sink, but mostly I remember her making biscuits with fig preserves.

Strawberry shortcake was often made using biscuits. Preserves could be used to top the biscuit if fresh strawberries were out of season. This simple recipe makes a quick, old-fashioned strawberry shortcake.

Strawberry Shortcake

¼ cup shortening
1 cup self-rising flour
⅓ cup milk
2 cups sliced strawberries, divided
½ cup sugar
1 tablespoon cornstarch
¼ cup water
1 cup sweetened whipped cream

Cut shortening into flour until it looks like coarse crumbs; stir in milk with a fork.

Dust hands with flour and pull off pieces of dough and hand-roll, making 12 tiny biscuits.

Place in cast-iron skillet and tap tops of each biscuit to flatten slightly.
Bake at 425 degrees for 12 minutes or until golden.
Mash 1 cup strawberries and mix with sugar; heat slowly.
Combine cornstarch and water and pour over heated berries, cooking
 and stirring until thick.
Stir in remaining sliced berries.
Slice open biscuit and top with strawberries and whipped cream.

Homemade biscuits and jam harken to the days of the Sunshine State's early settlers, but you can still find homemade jellies and jams for sale at roadside stands and other delicious sweet fruity spreads at markets and grocery stores. Jack and I picked up a few on our travels throughout the state. From Bradley's Country Store north of Tallahassee to home-canned pineapple preserves for sale at Yeehaw Junction in Central Florida and south to glistening rose petal jelly served at The Breakers in Palm Beach, you will find preserves, marmalades, conserves, jellies and jams along the way. Biscuits were not the only way to enjoy the fruits of your canning labor year-round. Jelly and jam were also used in cakes, cookies and pies.

Dishes and Beverage of the Old South provides recipes for preserving peaches, pears, plums or cherries and the following for a jelly pie:

Jelly Pie: (Louise Williams.) Beat the yolks of four eggs very light, with a cup of sugar, three-quarters cup creamed butter, and a glass of jelly, the tarter the better. Add a tablespoon vanilla and a dessert-spoonful of sifted cornmeal, then the whites of eggs beaten very stiff. Bake in crusts—this makes two fat pies. Meringue is optional—and unnecessary.

The Florida Tropical Cook Book provides recipes for jelly, preserves, jams and marmalade using the following Florida fruits: pineapple, kumquat, orange, mango, strawberry, loquat, figs, guavas, grapefruit and scuppernong. And in her classic *Cross Creek Cookery*, Rawlings tells stories along with recipes for preserving not only mayhaw, roselle, mango and loquat but also grapefruit marmalade and kumquat jelly.

As Jack and I crisscrossed the state, we acquired a variety of jellies and jams. If we are not putting some on a hot buttered biscuit, this is probably how we will use them. The kumquat chutney from the Kumquat Growers Inc. and the Florida orange marmalade we bought in Dade City will be passed along to my brother Pat, who has a fondness for

Rosa Fernandez Soto and Koreshan Edith C. Trebell, owner of the Tropical Fruit and Products Company, in Estero selling jellies, jams, candies and chutneys made by local women, circa 1960. *Photography Richard Byland and News-Press Publishing Company.*

Florida marmalade. The strawberry preserves from Parkesdale Farm Market in Plant City and A Matter of Taste in Dade City will be added to Jack's jelly shelf for all those peanut butter and jelly sandwiches he likes to make for lunch. Then there is the mango butter and blueberry preserves from A Matter of Taste, along with strawberry fig preserves and muscadine jelly from Bradley's Country Store; I will savor these in a pie or cake.

Since 1927, the Palmalito company has been making jelly in Florida. On the lid of the jar of their guava jelly, they suggest you "take a mini tropical vacation by adding a tablespoon of guava jelly to plain or vanilla yogurt." Some like guava jam with their hushpuppies. I think the Palmalito Jalapeño Pepper Jelly and the mayhaw hot pepper jelly from Bradley's Country Store will be good to put on a cracker with a dab of cream cheese. I'd like to try a bit of humor with Traffic Jam from Ridge Island Groves on my buttered toast. And there is so much more to choose from with places like Miller's Dutch Kitchen in Bradenton, Davidson of Dundee and

Postcard featuring tourists' attraction in Florida in the 1970s. *H.S. Crocker Co.*

Bob Roth's New River Groves in Davie. It seems as if many restaurants, country stores and gift shops are now providing a taste of Florida to take home in a jelly jar.

PS from Pat

Even though I am a fifth-generation Floridian, it was not until I was thirteen years old that I tried orange marmalade. One morning, my father tricked me into eating some on breakfast toast after he purchased a jar of marmalade during our second family vacation to Orlando in South Florida (most folks from northwest Florida consider anything below Gainesville South Florida). As a young teenager, even the name sounded old-fashioned and not so tasty. I figured it would taste musty, like it was made back in the olden days. It meant nothing to me that my dad loved it. After all, he liked collard greens better than mustard greens; I thought they both tasted like salted shoe inserts. So when my father forced me to taste it, other than the sugary sweetness, I hated it. When I was forty-something, I took my family on a "retracing my childhood" vacation to Central Florida. I bought a jar of orange marmalade from one of the roadside citrus shops, just to check and see if my taste buds had matured since 1974. Nowadays, it is a delight to eat.

Just recently, I talked my twenty-something-year-old daughter into putting some on her toast one morning. She hated it too. I realized I had given her the same pre-tasting pep talk my father had given me forty years prior. I still have a son who has not tried orange marmalade. He will probably like it just fine because he has already been to U.S. Army Ranger School and will eat anything.

Chapter 7

Ice Cream, Brittle, Nuts and Honey

From cake walks to cane grinding, taffy pulls to ice cream socials, sweets have been bringing communities together for centuries. Ice cream even became an edible symbol of morale during World War II as each branch of the military tried to outdo the others in serving ice cream to its troops. Hand-crank ice cream churns gave way to electric freezers, and now new ice cream parlors are popping up all over the state, and for good reason. Filling cups and cones with frozen treats is not only a summertime tradition; it's a year-round enjoyment.

From the nationally acclaimed strawberry milkshake at Parksdale Farm Market in Plant City to the nitrogen flash-chilled ice cream from ChillN in South Florida, we have a Florida man to thank, in part: John Gorrie. A museum honoring him is located in the historic town of Apalachicola. Dr. Gorrie arrived in 1833 and served as mayor, postmaster, city treasurer, council member, bank director and founder of Trinity Church. But it was Gorrie's dedication in the field of medicine that led to his invention of an ice-making machine and a cooling system for his yellow fever patients. He laid the foundation for refrigeration and air conditioning. Prior to home freezers, ice was harvested from places like Denham Lake near Ipswich, Massachusetts, and packed in sawdust to be shipped around the world. In 1914, a statue of John Gorrie was given by the State of Florida to the national Statuary Hall Collection to honor this physician, inventor and humanitarian.

From Marianna to Little Havana, ice cream shops in Florida experiment with flavors and tastes. Jack and I were intrigued with the process developed

Adrian Rodriguez working at ChillN in Fort Lauderdale. *Author's personal collection.*

by Danny Golik at ChillN Nitrogen Ice Cream. From the moment you step into the shop, you feel the difference. This fun and friendly place looks like a scientific lab reminiscent of high school chemistry class with a faux periodic table on the wall. With a closer look, you realize it shows the choices for your single serving of ice cream or yogurt, with the flavors and other optional ingredients for your made-to-order selection. Everything goes into a bowl as you watch the freezing process in a cloud of smoke, or really just the liquid nitrogen. The process is quick and entertaining, creating a dense and delicious frozen concoction. With stores located in the Fort Lauderdale to Miami area, this young company will surely grow, providing another way to cool off in the Sunshine State.

Adrian Rodriguez, lab technician or ice cream maker of the day, told me the most popular choice is Nutella, but he helped me with my selection of mango and almond. Starting out with the liquid cream, only minutes later I was handed a solidly frozen cup of ice cream. Honey, pecans, berries, coconut and seasonal selections of mango and pumpkin are only a few of the ingredients listed on their ice cream "periodic table."

Stepping back in time is what it felt like when Jack and I were greeted by Alicia Feliciano and Sheena Rapkin as we entered Jaxson's Ice Cream Parlor and Restaurant on Federal Highway in Dania Beach. Established in 1956, this nostalgic place offers over thirty flavors of ice cream and other dishes, including Tropical Delight, Towering Short Cakes, Chocolate Showers and Caramel Pecan Supreme, along with malts, shakes, sundaes, parfaits, floats, banana splits and more.

Heading west to Bonita Springs, we were delighted to find the locally popular and oldest ice cream store in the area, the Royal Scoop Ice Cream shop. The original store opened in 1979 and moved a couple of times before settling in on Eighth Street in the Bonita Shores neighborhood. The line was out the door, but Jack and I had a chance to talk with some Kentuckian tourists who seemed to be enjoying their selections. Mattie Acklin had a simple vanilla ice cream cone, Tara Acklin was enjoying her rocky road and Mary Barnett selected the praline. They all agreed it was delicious. Jack and I were pleasantly surprised to find Royal Scoop ice cream being served at the Coconut Point Hyatt Regency. When we arrived later that evening, Raquel Breitenstein artfully prepared three scoops of sweetness for our enjoyment.

The village of Siesta Key just south of Sarasota is also home to a local ice cream shop. The Big Olaf Creamery is named for the type of waffle cone first used in their shops, made from Big Olaf Cone Mix. Making waffle cones while the customers watched proved to be a big hit. According to their

website, "This was one of the first places in the state to offer the waffle cone and soon after, [Dennis] Yoder helped set up Busch Gardens and Sea World with equipment and mix for them to bake this new kind of cone." Yoder opened the shop on Siesta Key in 1982. Growing from one location to a multitude of stores is a sign they must be doing something right. They also offer soft serve, smoothies, fudge and milkshakes.

The Candy Kitchen has been scooping up ice cream and other sweet treats since 1950 at the Madeira Beach location, with two newer locations at Redington Shores and Indian Rocks Beach. Strachan's Homemade Ice Cream in the Tampa Bay area has been around since 1999, with the first location in Palm Harbor and now another in Dunedin.

Uncle Andy's Ice Cream Parlor, located in the Don CeSar hotel on St. Pete Beach, is home to an old-fashioned ice cream shop offering sundaes, shakes and banana splits featuring Florida-based, family-owned Working Cow Homemade Ice Cream. Alexandra Cahn and Karen Wayes described the Captain Butterscotch as the most unusual flavor and the salted caramel with dark chocolate as the trendy favorite. Laura Storch, Lindsey Letchworth and Jasmirra Coral were working at the Auburndale Shake Shop the day Jack and I stopped by for an ice cream treat. They highly recommended the Trash Can sundae, full of broken-up pieces of all my favorite candies. It was like a bucket of Halloween candy in a sundae.

A favorite of Debbie Crosby, of the Grove House in Lake Wales, is Andy's Igloo or, as another sign on the property proclaims, Andy's Drive-In Restaurant. This Winter Haven landmark was established in 1951 and still has the look and feel of an old-fashioned diner. One-time popular eating place for the Cleveland Indians spring training team, it's still popular with locals and tourists alike. Debbie recommended the banana split, which Jack and I enjoyed along with a nostalgic look back, trying to remember the last time we had split a banana split. Peggy Macdonald of the Matheson Museum highly recommends Sweet Dreams in Gainesville, where she enjoyed many cones as a kid in the '70s and '80s. And then there is the original Dreamette, in the Murry Hill neighborhood of Jacksonville, serving ice cream treats since 1948. Ordering a chocolate-dipped vanilla soft-serve from a walk-up window is reminiscent of days gone by.

But times have changed, and so has the ice cream–making industry. If you want to open an ice cream shop, you could attend ice cream college first to make sure you get it just right, and that is what two Florida shops did. The country and the Cuban ice cream stores both got some of their training from Penn State's Ice Cream University. Lucky for us, they opened shops in

BASSETT DAIRIES.
"FROM THE SUWANEE TO THE APALACHICOLA"
2001 N. MONROE STREET

Bassett Dairies ice cream counter on Monroe Street in Tallahassee, 1949.

the Sunshine State. Southern Craft Creamery, in Marianna, wants to ensure every aspect of the ice cream they sell reflects their philosophy of serving interesting flavors using local ingredients. Using non-homogenized milk from their Florida farm, the handcrafted ice cream is flavored with naturally sweet Florida honey, peaches and strawberries. Those were the three flavors I picked up at Bradley's Country Store just north of Tallahassee. Butterscotch and vanilla were two of the many flavors offered at Buck's Piggly Wiggly Express in Fountain. This gourmet ice cream is also featured on menus at Charley's steakhouses in Kissimmee, Orlando and Tampa.

Across the street from the historic Maximo Gomez Park, filled with cigar-smoking guayabera-wearing men playing dominos, is the Azucar Ice Cream Company. *Azucar* is the Spanish word for sugar, and this sweet shop is located in the heart of Little Havana on Calle Ocho near downtown Miami. They offer Latino-influenced ice cream and sorbets. Owner Suzy Batlle was recently dubbed the "Queen of Ice Cream" by *Ocean Drive* magazine. It was her *abuela* (Cuban grandmother) and *abuelo* (grandfather) who were instrumental in shaping her adulthood and eventually led to the opening of an ice cream shop. The flavors are based on what she remembers Abuela creating as she was growing up, such as mamey, avocado, café con leche, plantain, guava, coconut and mango, with over fifty seasonally changing flavors of ice cream and sorbets.

Barbra McGarrah did not want to see those tiny pieces of leftover peanut brittle in the bottom of the bag or bowl go to waste, so she added them to ice cream and found it to be delicious. But she didn't stop there. She also combines them with candies and cookies in her gourmet sweet shop. Barb's Southern Style Gourmet Brittles, Candy and Ice Cream, located in a sweet little cottage on Lake Ella in Tallahassee, has been serving over twenty-five different flavors of brittles, along with other gourmet treats, for about fifteen years. But it all started when she did not want to see what was left of a big ol' one-hundred-pound bag of peanuts go to waste.

McGarrah was born on national peanut brittle day but did not find her calling in the brittle business until after a successful career in fashion design. One of eleven children, when it came time for college, so many family and friends helped her along the way, and she wanted to show her appreciation. One Christmas, she decided to give something homemade to each of them. Her father got her a bag of blanched peanuts, and she soon found that one hundred pounds of peanuts will go a long way when making peanut brittle. She still had fifty pounds left after her gift-giving and decided she would sell her brittle at a local craft show, just to use up all those peanuts. Ready to get back to fashion design and sewing, she was called on again and again to make her brittle for local events and businesses. When she realized she had to choose between her design dreams or her natural candy-making talent, McGarrah decided she would combine her creativity with candy making and opened her store. It's not just peanut brittle anymore. She makes sunflower seed, coconut, almond, cashew, pecan, macadamia, pistachio and virgin brittle for those who don't want nuts. As I was flying out of the Tallahassee airport, I saw bags and bags of her brittle for sale in the gift shop. It just made me smile.

Florida is full of nuts, from peanuts to pecans, and the J.W. Renfroe Pecan Company and Gift Shop has been in the nut business since 1956. The day I stopped by, Dee Renfroe told me about the company and how her family started the retail store and mail-order business. For three generations, the company has persevered and grown by changing with the times. In the 1930s, J.W. Renfroe Sr. started buying and selling in-shell pecans in Troy, Alabama. He was shipping truckloads of in-shell nuts out of state to be processed. Then in the mid-'70s, J.W. Renfroe Jr. moved the business to Pensacola and opened a retail store to sell the nuts directly to consumers. By 1976, they had started a mail-order business. Now Dee and her brother, Jake Renfroe III, are in charge. The pecans come from surrounding states as well as Florida, but they sell all kinds of nuts. They sort, size, sanitize, crack, shell, dry, inspect and bag the pecans themselves. The gift shop is a hidden gem along with the fudge, pralines and other goodies. You can purchase pecan pie and pecan candy or follow one of the recipes on their website to enjoy these Panhandle pecans and make a chocolate pecan chess pie or pecan shortbread cookies. Their retail store is located on the corner of Fairfield Drive and North S Street.

Robinson's Pecan House is another kind of retail outlet, selling nuts, tupelo honey, cane syrup, pecan rolls, peanut brittle, jelly and more at a roadside stand in Lamont, along U.S. 27, east of Tallahassee. This is not a place you can call to see if they are open, but if you do stop by, you might find proprietor Arthur Robinson, a charming and interesting storyteller. The first time I met him, I was in search of tupelo honey but walked away with so much more. Here is hoping the next time I am driving between Tallahassee and Perry, Robinson's Pecan House will be open.

After our South Alabama family reunions, we would bring home bags full of pecans that still needed to be shelled. If you have ever shelled pecans, then you know how tedious and time consuming it can be just to render enough nuts for one pecan pie, especially when you eat more than you save for the pie. We would also look for perfectly intact whole pecans to garnish the top of the pie, so eating the broken pieces was perfectly acceptable. The pecan pie recipe my relatives used was probably off the bottle of white corn syrup, better known as Karo. Our son, Jackson, once said that anything made with Karo syrup is addictive. He may be right, but I have substituted Florida cane syrup or honey in many of the recipes and have equally addictive desserts.

My sister-in-law Laurelyn Winter Sheffield gave my mother, GrandMary, a recipe for peanut butter balls. GrandMary began making them for her grandchildren when they were younger. She made some recently when

Beekeepers Esta Lee Glenn and Edgar T. Lanier in the 1930s, at the Lanier Apiary in Wewahitchka.

Jackson came for a visit, and he said they are still as good as he remembers. Peanut butter was created in 1890 to provide a nutritious, easily digestible food for the elderly. Couple that with fortified cereal and you have a peanut butter breakfast treat. The combination of those two ingredients, along with a little corn syrup, a splash of vanilla and sugar, makes up this recipe for peanut butter balls.

Laurelyn's Peanut Butter Balls

1 cup sugar
1 cup light corn syrup (Karo)
1½ cups creamy peanut butter
1 teaspoon vanilla extract
5 cups corn flakes

In a large microwave-safe bowl, combine sugar and syrup; cook on high for 3 minutes.
Stir, and then cook 1 additional minute if sugar is not yet dissolved.
Stir in peanut butter and vanilla; mix well.
Gently stir in corn flakes and mix to evenly coat cereal.

While mixture is still warm, butter your hands then form mixture into
 1-inch balls.
Let cool completely.

The Florida Tropical Cook Book has over twenty recipes using honey, from honey caramels to a honey drink. It includes gems, jumbles, cookies, candies, cakes and tips, such as suggesting using honey instead of sugar or molasses to keep the cake moist longer. When the book was written in 1912, honey was not as easily found as it is today in grocery stores, roadside stands and farmers' markets. The choices we have are only limited by the beehive's location. The bees convert sweet nectar into honey and store it in honeycombs, and that is how we are blessed with a variety of flavors such as Key lime, gallberry, ti-ti, tupelo, black gum, willow, palmetto, avocado, mangrove, orange blossom, sea grape, mango, wildflower and even Brazilian pepper.

At the annual Tupelo Honey Festival in Wewahitchka, you can taste and take home fine tupelo honey. Glynnis Lanier, of L.L. Lanier & Son's Tupelo Honey, is a honey expert, particularly on tupelo honey. Glynnis married into a family with deep roots in the tupelo honey business. Lavernor Laveon "L.L." Lanier Sr. started the Tupelo Honey Company in the 1890s; L.L. Lanier Jr. and his wife, Martha, took over in the 1940s; and now Ben and his wife, Glynnis, operate the family business. Three generations in the honey business for more than a century qualifies them as experts in the only flavor of honey they bottle, tupelo.

The price of tupelo honey is usually much higher than other honey due to its short blooming season of a few weeks in April and May. It is also difficult to reach the trees found in the Apalachicola River Valley surrounding the Wewahitchka area, and then there is the added work of placing the beehives on mounds to keep the murky, swampy water at bay. Each year, the weather plays a role in predicting the flow of honey for the season, and the unpredictability is sometimes disappointing. A unique trait is that tupelo honey does not crystallize like most other honey. Glynnis shared some fascinating information with me about tupelo honey and why it's so special:

> *The quality of the honey falls to the beekeeper knowing what he is doing. Knowing when to take the honey before the bloom and after. There is a white tupelo and a black tupelo tree. The honey is made from the white tree. The black tree makes a darker honey that will crystalize and is sold as a bakery honey. Price drives a lot of people; however, you usually get what you pay for. This is almost always the case with honey.*

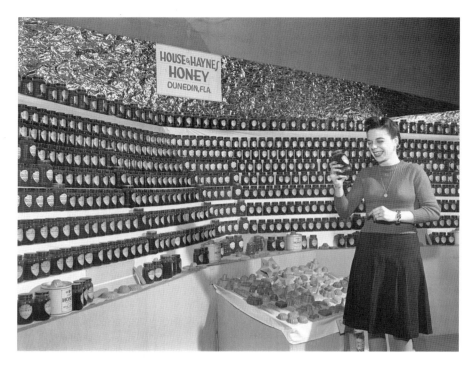

Barbara Tynos enjoying the honey exhibit at the 1947 Florida State Fair in Tampa.

We like to bottle just the tupelo. Who knows where the other honey is coming from. Most of the tupelo on the market is not tupelo. People will label anything tupelo. When someone is buying honey, they should know who they are buying it from. Know the beekeeper and the quality of honey. This is with any type of honey. If you want the best, find the best beekeeper and honey producer. Our honey can be purchased online at www. lltupelohoney.com or at our store, 318 Lake Grove Road, Wewahitchka. I use honey in my coffee every morning, and I never tire of it. I can't stand my coffee without it. Tupelo honey brings out the flavors of other foods.

Varietal honey is collected from one source or only one type of flower, while other bottles of honey might contain a blend of nectar and pollen from several varieties. It seems as though today there are more and more stacks of white boxes filled with drawers in open fields (man-made beehives), among the groves and along riverbanks than we have seen before. The Curtis Honey Company in LaBelle has been serving up honey exclusively

from southwest Florida since 1954. They offer more than just jars or jugs of honey by selling honey products such as beeswax candles and honey-filled candy. The collecting and selling of honey has to be a labor of love, and it seems more and more people are getting into the business.

For local honey, farmers' markets are a great place to start looking. While attending the Palafox Market in Pensacola, we discovered a selection of wildflower honey from the East Hill Honey Company. Tommy Van Horn, owner and beekeeper, and Brendan Connelly were manning the booth the day I stopped by, and they patiently answered my questions about bees and honey. I learned a lot. For instance, they move the hives from place to place as necessary to keep the honey flowing. Crafting pure raw honey from his Gulf Coast apiaries is a passion of Van Horn's, and he hopes to instill in others a sense of community by working together to bring honey home for all to enjoy. According to his website, www.easthillhoney.com:

> *Every jar of honey has a story. Where it was sourced, from what flowers, in what climate, how are the bees kept, who is the beekeeper, why is he/ she a keeper? Our mission is to tell the story of each jar and to connect our neighbors and customers to the details and healing powers of raw honey. Our honey is sweeter because it is not mass produced, but rather, it is handcrafted by a small community of beekeepers dedicated to growing in virtue, serving the community and cultivating sustainability. When you purchase East Hill Honey—you are not only receiving the benefits of raw honey, you are also making it possible for the next generation to be mentored with a new, holistic approach.*

Another honey haven we found was in Monticello at Tupelo's Bakery and Café on Highway 90 near Courthouse Circle. The caramel pecan bars are advertised as addictive, and I agree. It is a bakery, café and honey shop, with bakery items and honey gifts, from books to beeswax. The Full Moon Farm Store located within the bakery features the local honey they produce.

PS from Pat

Summer days in Florida were as hot and humid in the 1960s as they are today. It wasn't until I was in second grade that we got air conditioning in the house and fourth grade when we got a car that had AC. So ice cream was a special treat. I would watch Dad adding

all the ingredients into the ice cream machine. I was about seven years old at the time. I remember you had to have cream, sugar, vanilla, ice and rock salt. We almost always had plain vanilla ice cream. An ice-cold scoop of ice cream in a bowl not only tasted good, it looked good. The family talked big about making different flavors of ice cream such as blueberry, banana, peach or strawberry. We never did make anything except vanilla, probably because we could never agree on the flavor.

After visiting our grandparents during the late summer and fall, we would return home with fresh North Florida/South Alabama peanuts for boiling and making peanut brittle. Like pecan pie, the peanut brittle was always made with Karo brand syrup and fresh peanuts, or ground peas, as my father called them. The ground peas we used were the little Valencia Spanish variety, not the big Virginia peanut-butter peanuts. After Mom would cook up the brittle, with me standing right beside her, like a dog waiting for table scrap to fall on the floor, she would pour the contents onto the greased-down countertop. It would take an hour or so for the cooked syrup and peanut mixture to harden. After much begging, she would allow me to break the brittle into small bite-sized sections. I learned from experience, if you try to eat it too soon, it sticks to your teeth.

Chapter 8

Taffy, Toffee, Tourists and Chocolate

Jack and I were staying at the Fontainebleau Miami Beach, doing more research (wink-wink). After check-in, we saw the whimsical display of cookies and cakes as we walked past the coffee shop, Chez Bon Bon. A square red velvet cake and glistening flip-flop-shaped cookies were only two of the luscious-looking desserts on display. Ready for coffee and something sweet the next morning, I was intrigued to see a Florida orange mocha on the menu. It reminded me of the exotic flavors offered to vacationers during the Gilded Age at luxury resorts along the coast. It was the perfect combination of orange zest, chocolate and coffee and brought back memories of those chocolate-orange-flavored candies popular at Christmastime.

The Gilded Age, from the 1880s to the 1890s, was spurred on by the introduction of railroad lines crisscrossing the state. From St. Augustine to the Keys, new foods and supplies were introduced to cooks, adding more variety to the sweet dishes being served in homes and restaurants. On January 10, 1888, opening night of Henry Flagler's Hotel Ponce de Leon in St. Augustine, the menu included the following assortment of desserts: pudding, soufflé à la vanilla, apple pie, coconut pie, chocolate éclairs, calf's-foot jelly, assorted cake, fruitcake, vanilla ice cream, fruit, cheese and coffee. The lunch menu on February 26, 1888, offered stewed prunes, apple pie, pumpkin pie, gingersnaps, lady cake, croquettes Parisiennes, assorted cake, pistachio ice cream, fruit, American and foreign cheese, tea and coffee. Across the street from the former Hotel Ponce de Leon, now Flagler College, is the Casa Monica Hotel, which once served Turkish coffee to elite travelers.

Map of Florida showing the location of three leading winter resorts in 1885, in Tallahassee, St. Augustine and Sanford. *J.M. Lee.*

From the same corner where the gourmet coffee shop was located, you can now sip a latte from a popular chain coffee shop, as you mull over five hundred years of history in the area when Florida was becoming a mecca for wealthy tourists and more glorious hotels were built along the shorelines and rail lines.

Designated a National Historic Landmark in Palm Beach, The Breakers Hotel continues to operate as a luxury resort. White Hall, also built by Henry Flagler as a winter home, houses the Flagler Museum, seasonally serving high tea with sandwiches, scones and sweets. Henry Bradley Plant's Tampa Bay Hotel, another National Historic Landmark, is now home to the

University of Tampa and the Henry B. Plant Museum. "Plant's Palace," as it was dubbed, served elaborate meals in its domed dining room. A dinner menu from Sunday, July 25, 1903, lists the desserts for that evening as chocolate soufflé pudding with vanilla sauce, Charlotte Russe, custard pie, nougat ice cream, strawberries à la Française and assorted cake.

The turn of the twentieth century saw changes in our diets, daily lifestyles and vacation destinations. It was the beginning of a luxurious lifestyle for many with telephones, indoor plumbing, electrical appliances, washing machines and automobiles. The introduction of home economics in schools helped to encourage nutrition education, and oranges were being promoted as an excellent source of Vitamin C for a well-balanced breakfast. More affordable hotels were popping up throughout the state; some of those vestiges of old Florida still exist, such as the Historic Seminole Inn in Indiantown. Located about thirty miles northwest of West Palm Beach, this town was planned as a model community and the headquarters for the Seaboard Airline Railroad. The 1930s were an era of Art Deco in Miami and Miami Beach, but it wasn't until after World War II that Florida really saw a population and tourism boom. Some of the luxury hotels became home to soldiers as they trained for and recovered from World War II. Those same troops spread the word of the paradise that Florida had become. Air conditioning and mosquito control complemented the breezes off the Atlantic Ocean and the rolling surf of the Gulf of Mexico. Roadside attractions were becoming popular. Hula-hoops and drive-in theaters were sources of entertainment. The remnants of many of those hotels, motels and motor inns can still be seen along the back roads and rail lines.

The former family-run Chalet Suzanne, a Swiss-style village built in 1931, was set amidst an orange grove. One drizzly evening, Jack and I watched through the dining room window as a plane slid onto the private runway and then on into Lake Suzanne. Everyone was fine, just a little wet, as they enjoyed their meal. People flew in just to have dinner, which began with honey- and butter-filled, cinnamon sugar–topped, broiled grapefruit. Bertha Hinshaw provided her recipe for baked grapefruit in *Famous Florida Chefs' Favorite Citrus Recipes*, published by the Florida Department of Citrus in 1972. In the 1950s and '60s, the Modern period spawned the growth of suburbs. Tupperware and Tang were introduced, and then the theme parks of the 1970s changed the look of the state most dramatically. Epcot in the 1980s and Emeril in the 1990s became household words. When the Food Network got started, Jack and his friend Charles Knight, owner of HealthCraft Cookware, were a part of some of the first programming.

Postcard for the Chalet Suzanne, opened in 1931 in Lake Wales, with a note: "Orange juice and coffee served in your room before breakfast."

Jack can't cook but served as a host as Charles demonstrated his product, cooking everything from a full dinner to desserts.

Marko's Heritage Inn, a Port Orange landmark near Dayton Beach, was a popular dining destination. Peggy Macdonald recalls the palate-cleansing orange sorbet. This trendy course was oftentimes deemed dessert by many happy children dining with their parents, and Peggy was no exception. Around the same time Marko's Heritage Inn opened in the 1950s, a candy shop on Daytona Beach got started, called Zeno's. An old-fashioned taffy-pulling machine proudly displayed in the storefront widow, both on the Daytona Beach and John's Pass boardwalks, makes it hard to walk past Zeno's without taking a look. With over one hundred flavors of taffy and other candies, it appears third-generation owner John Zeno Louizes has the same determination to succeed as his father, Zeno Louizes, and great-uncle Thomas Nougaras. They started the business in 1948, bringing their taffy-making skills from Coney Island. Elizabeth Milton, in the 1978 article "How Sweet It Is" for the *Daytona Beach News Journal*, recounted how the candy maker on Main Street was making eleven flavors of taffy on a burner in the back of the store, using a taffy puller and candy-wrapping machine to finish the sweet treat. With repeat local customers and seasonal tourists, the colorful shop always seems busy. As she was refilling the pastel-colored buckets of taffy, Emilee Leisten, sales associate at the John's Pass store, told me this is her dream job, working at a candy store on the beach, after moving here from Chicago about a year ago.

Zeno's World Famous Taffy is named in honor of its location on the world's most famous beaches. Some of the more nontraditional flavors are maple bacon, beer, mojito and red tide. The more traditional include the bestsellers of vanilla, chocolate and fruit punch. Other favorites are banana, cotton candy, mango, honey, Key lime, guava, tangerine, blueberry, coconut, watermelon, birthday cake and strawberry.

For me, toffee is one of the most perfect candies, with its buttery-crunchy-nutty center and chocolate coating. Toffee-to-Go opened in South Tampa over fifteen years ago just down the road from my home. The first time I tasted a sample of their toffee was in a gift shop, and I ended up buying toffee for everyone on my Christmas list. Then I discovered their tiny shop tucked away in a neighborhood office building. I still remember the lady working that day telling me to be sure to sprinkle any leftover toffee on a scoop of ice cream, as it makes a great dessert.

Toffee-to-Go has since moved to a larger store and now makes its toffee in a warehouse off-premises. That is because the toffee is so good and in

TAFFY

Have I got a pull with you?

Antique taffy pull postcard. *Author's personal collection.*

such high demand that it outgrew its first location. This nationally acclaimed award-winning candy is still made by hand in small batches. It is hard to resist stopping in each time I drive by the place. The variety of flavors includes milk chocolate almond, dark chocolate pecan and white chocolate macadamia nut. Toffee makers Jim and Lisa Schalk follow an old family recipe using farm-fresh butter and premium chocolates to create a toffee that tastes like homemade. Lisa shared with me that they are excited to be expanding the shop to include a dessert room, featuring more favorite Florida sweets by serving Working Cow Homemade Ice Cream, Indigo Coffee and a one-time local and now national favorite, Mike's Pies. Mike Martin of Mike's Pies is another Tampa success story; by starting out small, he is now nationally acclaimed as one of the best pie makers in the country.

Beginning in the late 1930s and up until the early 1970s, Stucky's advertised a divinity-like filled pecan log on billboards throughout the state. Now we have Orlando-based Anastasia Confections filling the void with chocolate alligators and chocolate-covered coconut patties. These Sunshine State souvenirs can be found in airports, tourist shops and drugstores throughout the state.

For something hand crafted, we are home to a great number of chocolatiers, some small, some nationally known and some that have had their chocolates appear in blockbuster movies. Chocolate has been a part of Florida history for centuries. One of the first written accounts of survival in the Florida wilderness comes from *Jonathan Dickinson's Journal*, written circa 1699. It is his personal account of a shipwreck survival off the southeast coast of Florida with his family and a few others. On November 16, 1696, Jonathan Dickinson wrote, "The governor came in this morning to our apartment, inquiring how we did. And we having had chocolate for breakfast, he asked if we would have anything else his house could afford. If we would but ask, it should be brought to us. But we modestly answered that this was sufficient although our appetites were not to be satisfied."

In *A History of Food*, Maguelonne Toussaint-Samat covers the subject of how chocolate has become a common candy. Missionary nuns in Central America used vanilla, cream and sugar to enhance the flavor of chocolate, with wonderful results. By 1585, its fame had spread to Europe. Laced with cinnamon, they drank it all day long. By the late 1600s, as a drink it cost more than twice as much as coffee or tea. In the 1700s, chocolate manufacturing was beginning, and by the 1800s, the Swiss had perfected milk chocolate, followed by Nestle in the 1900s. From the bean to the bar, the sweet success of chocolatiers in Florida is growing.

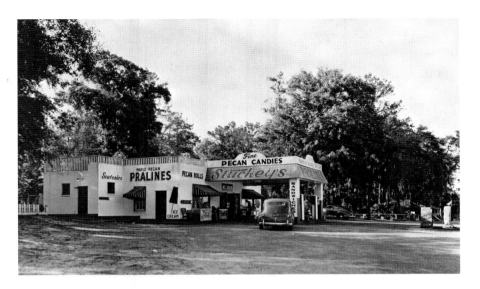

Stuckey's Candy Shoppe in Hilliard, on U.S. Highway 1, in the 1940s.

Sweet Pete's is a sweet treat with two Florida locations, one in Key West as part of the Key Lime Pie Company and another in the historic 1903 Seminole Club building in downtown Jacksonville. In 2014, Sweet Pete's candy store got a boost from the TV show *The Profit*, and now the Jacksonville store offers candy-making classes and factory tours, along with hundreds of candies, chocolates and other tasty confections.

The place to go for chocolates in the Keys is Chocolatier Kristie Thomas's Key Largo Chocolates, located at MM 100.5. The lime green and flamingo pink décor complements the display overflowing with not only chocolates and fudge but also sweetness such as tropical ice cream, Key lime truffles and cake pops. Family owned and operated Miami Beach Chocolates opened in 2009, and this delightful shop offers a variety of chocolates, including dairy-free and kosher, cholor Yisroel and Parve candies, along with a wide assortment of milk chocolate. The citrus and fruit chocolate-dipped candy and the citrus nut square are a reflection of the Sunshine State. Jack and I enjoyed three popular pieces: the white chocolate cheesecake, the crunchy chocolate bite and the chocolate peanut butter.

Reading the billboard as you enter town, Angell and Phelps offers free chocolate-making tours. Located on King Street in Daytona Beach, the original store was founded by Riddell Angell and Cora Phelps in 1925 on Mackinac Island in Michigan. They moved to Daytona Beach at the start of

From the Louise Frisbie collection, circa 1910 advertisement by the Unites States Railroad Administration.

World War II, when Florida would soon be experiencing a population boom of tourists. Under new management since then, they still use many of the original recipes.

Bill Day has been working at the Ritz-Carlton on Amelia Island since it opened over twenty-five years ago. He remembers fondly taking his young daughter Kalie to Fantastic Fudge in nearby Fernandina Beach. This family-owned business offers marble slab fudge, hand-dipped chocolates and ice cream and waffle cones. Sirard's Chocolate, located in Sarasota, offers truffles, cake and chocolate-dipped pretzels. Carol Sirard's Café and Chocolate Shop also serves lunch and dinner, with almost every item featuring some type of chocolate. Jack and I made the right decision when we stopped by to pick up my favorite, Sarasota Seafoam, a chocolate-dipped caramel crunch, and we decided to stay for lunch.

The moment you walk in the door of Oh My Chocolates in downtown West Palm Beach, you are greeted by a chocolate coziness nestled among what seems like thousands of stuffed animals. Owner Flor Reymond Nordine is as sweet as her chocolates and shared her story of learning the chocolate-making craft from the masters in Italy. She wanted to know how to make chocolate for herself and ended up opening a store. Now, she makes her family recipes of handmade artisan chocolates. Her chocolates are infused with fruit purees, juices, oils and liqueurs, and she adds fresh spices and nuts to create over seventy varieties of confections. Nordine helped me select some of her favorite chocolates, which included peanut butter, mochas, liqueurs and butter almond. In addition to creamy caramels, truffles, gourmet apples and butter toffees, she offers custom gelato, made fresh daily. Taking a taste of the mango and strawberry gelato was like taking a bite out of a fresh strawberry and a juicy mango.

Peterbrooke Chocolatier began in 1983 when Phyllis Lockwood Geiger opened her first shop in the historic Jacksonville neighborhood of San Marco. Named after her children Peter and Brooke, it started with homemade chocolate-covered popcorn for a holiday festival and grew into dozens of stores throughout the southeastern United States. Geiger sold the company in 2009, but the brand is still home to chocolate-covered cookies, pretzels and fresh crunchy popcorn. When I visited the store in Palm Beach, pastry chef and chocolatier Candice Vasconcellos was working that day and told me everyone calls her Candy. Candy making candy seemed a natural calling for her, as she mixed, poured and tempered the chocolate that day in the store. The store in Winter Park, at the corner of New England Avenue and Park Avenue, is one of our favorite chocolate

shops. Watching through the window, Jack was mesmerized by candy making and the display of real-looking pink, blue and white chocolate shoes. "Can you eat them?" he wondered out loud, and the candy lady nodded yes through the glass window.

What started out as an ice cream store on St. George Street, the factory and downtown retail store of Whetstone Chocolates of St. Augustine is located at 139 King Street with other stores in the historic district and Anastasia Island. Assistant manager Sally Toole and tour guide Joe Higgins (or, as he likes to refer to himself, the *eye candy* for St. Augustine) are proud to work for the Whetstone family. The tours introduce the history of chocolate making and the Whetstone story. "Taste freshly made chocolates and confections while you walk through our factory" is part of their advertising slogan. Florida natives Henry and Esther Whetstone began selling ice cream in the late 1960s and then created a homemade fudge recipe to add to the menu. Increasing demand for their fudge led them to move to a larger location in the 1970s on Cordova Street, which now includes a ten-thousand-square-foot factory and store.

From Naples and Bonita Springs to Fort Myers, internationally acclaimed pastry chef and chocolatier Norman Love has combined both talents to create works of art that taste as good as they look. It's almost like stepping into an art gallery when you enter Norman Love Confections. Featured in national magazines and televisions shows, in 2009, Love was named one of the top ten chocolatiers in North America by *Dessert Magazine*. *National Geographic* named him one of the top ten in the world. Natasha Volney at the Estero store told me about the candy-making demonstrations offered at his main store in Fort Myers. Each piece of chocolate is created by hand with the help of Love's team of artisans.

William Dean Chocolates, founded in 2007, is named in honor of Bill Brown's father, William, and his grandfather Dean. Bill Brown is the creative mind behind the handcrafted and hand-painted small-batch artisan chocolates. With a background in education, when the time came to search for a new job, his passion for drawing in his younger days led to his talent for painting chocolates. On a recent trip to the International Plaza store in Tampa, Marsha Celic, retail manager, and Patti Thomas, sales associate, helped with my selection of chocolates, explaining why Dean Chocolates are so special. Then they carefully placed each piece in the equally artfully designed box.

The Belleair Bluffs shop caught the attention of Wes Mullins when he moved to Florida looking for a job. His middle name is Dean, and he thought

to himself, *This might just be the place for me.* He walked in the door when Celic was working, and she hired him right on the spot.

When I asked Brown if there is anything he would like to share about his life as a chocolate creator in Florida, here is what he said:

> *It's more than I could ever have asked for. As someone who spent most of my life working for others it is a real joy to come to work and do something I love. I've been very fortunate to meet and learn from some of the best chocolatiers in the world. It has helped me improve my craft, and I was honored in 2014 to be named one of the Top 10 Chocolatiers in North America by* Dessert Professional. *In 2015, our chocolates were rated third best in the world, with the highest rating of any U.S. chocolatier, in the most comprehensive book on artisan chocolates book,* Chocolate: The Reference Standard, *by Georg Bernardini. It's been a great adventure so far, and I'm proud of all we've accomplished. Most of all, I'm proud that we have not cheapened our product and continue to use the best chocolate we can (primarily Valrhona and Felchlin). We stay true to what we make, our craft and product, and keep striving to improve it, and I'm so pleased that our customers appreciate it. It's easy to cheapen a product to make more profits, but I'm glad our route has been to improve where we can and our awards and reputation reflect that commitment to quality. I can't even imagine my life without chocolate; it has been my medium and vehicle to share who I am with the world.*

In 2012, Brown discovered his masterpieces had a sweet spot in the popular Hunger Games films when he sat down at a theater and saw them on the big screen. Then in 2013, the salted caramel was rated one of the top ten chocolates in the United States by the *New York Times*; it is now the most popular. Other popular flavors are Key lime, PB Krunch, lavender, dulce de leche, mint pie, WD 64% and passion fruit. Aside from the two stores, William Dean Chocolates are also sold by several local retailers, including Datz, Dough, Locale Market, Duckweed and Tebella. It's not only his chocolates that are a vision of beauty; his boxes are clever and cute as well. He worked with the box manufacturer to select the signature blue and gold colors for a look and feel of elegance. What inspires Bill Brown to create these miniature works of art that vanish in one or two bites?

> *I wish I knew; they come to me from very different sources. Typically, it is my interpretation of the flavor, and in some cases it may have elements of*

more than just the taste. Key lime, for example, is green as you would expect, but I did a random pattern with bright orange because it reminded me of tree frogs that are tropical like Key limes. Passionfruit is orange, purple and red, as ripe passionfruits have some of these colors. The outside is typically purple/reddish, and the juice is orange. For cappuccino, I imagine as a very milk-based flavor, so the shell is white with flecks of black, brown and gold to reflect the coffee and cinnamon. Sometimes it is just to try a new technique like our Caribbean caramel. I came up with a technique that wipes out a pattern, and then you spray another color behind and it has a neat effect. In this case, I thought the black and orange were dramatic, so I chose that look, although it has little to do with the flavor.

PS from Pat

Except for Halloween, an occasional bag of chocolate-covered peanuts from the Sears & Roebuck candy stand or when Cousin Kathy would buy me a candy bar, I did not eat much store-bought candy. I just did not have the money for that. Heck, I did not have any money for anything. Back in the '60s, Snickers bars, Hershey bars and such were all a dime each. But a Zero candy bar was only a nickel. A bottle of Coke was a dime. If you would stay at the store with the drink, you would not have to pay the bottle deposit. But Cokes were only ten ounces in volume, while RC Cola sold in larger-sized sixteen-ounce bottles. Every week, my mom would give me a dime to pay for the Cub Scout weekly dues. Each week, my childhood best friend Mike and I would not pay our dues money at the Cub Scout meetings that were held in the den mother's trailer at Dykes Trailer Court. With dimes in pocket, after the Cub Scout meetings, on the walk home, we stopped by the Minute Saver convenience store. With our dues money pooled together, plus an extra penny we'd have to bring to cover the tax, we had twenty-one cents. We each bought a full-sized Zero candy bar and split an RC Cola. This went on for several weeks. We thought we had our own Parker Florida Ponzi scheme going until we got busted. When our back dues built up to one dollar each that we owed to the Boy Scouts of America, the den mother said that me and my buddy had to pay the back dues when we showed up to the next meeting. As much as we both liked Cub Scouts, we knew we could never raise one dollar each in one short week, so we stopped going. As far as both moms knew, for about another month or two, we were still Cub Scouts and going to meetings. From then on, each week on the meeting days we continued the charade of wearing our Cub Scout outfits and supposedly headed off the meeting. We actually went to the Minute Saver to get a candy bar and RC Cola, followed by an hour of play at the Parker Elementary School playground. Not sure why we stopped, because we never got busted.

Chapter 9

Darling Doughnuts, Tropical Treats and Ethnic Sweets

Homemade doughnuts and the ones purchased from a shop around the corner have been around for ages. Now they are also on dessert menus in restaurants, served along with the best pies and cakes one has to offer. *The Florida Tropical Cook Book* features Mrs. McClure's 1912 recipe for doughnuts: "One cupful granulated sugar, four tablespoons melted lard, one well beaten egg, one cup sour milk, level teaspoonful soda, pinch of salt and flour enough to make a soft dough." By the 1950s, a shortcut for making doughnuts at home using canned biscuits was popular: "Cut a hole in the biscuit with a doughnut cutter, drop both pieces in hot, bubbling, oil and cook until golden brown on all sides. Remove from oil with a slotted spoon, drop into a paper bag filled with confectioners' sugar and shake." When I threatened to run away from home at the age of five, my mother said, "Go if you want to, but I'm making doughnuts." I never regretted my decision to stay. With so many choices for doughnuts today, I have limited my selections to a few places that show a progression from doughnut shop to bakery to café.

The DoNut Shop in Niceville first opened it 1966 but has been owned by "Granny Jean" since 1990. According to her granddaughter Geneane, Granny Jean was pregnant with Geneane's uncle Mark in the 1970s when she was working at the shop. Today, Granny Jean and Uncle Mark own the shop. They must be doing something right since they sell out early every morning. The shop, located on John Sims Parkway, opens every day at 5:30 a.m., and by 9:30 a.m., the trays are almost empty. I ordered my blueberry-

filled doughnut for ninety cents at the walk-up window and left a donation in a jar by the window, marked "Donations for the USO." This simple shop was simply delightful.

The charming village of Mount Dora, established in 1880, located on Lake Dora, is just under an hour north of Orlando. While browsing through the independent bookstore Barrel of Books and Games, I asked one of the owners, Crissy Stile, to suggest a place for something sweet to eat. She didn't hesitate and recommended Le Petit Sweet, just a few blocks away. Even though everything in downtown Mount Dora is "just a few blocks away," the town has so much to offer. I found it funny that the gun shop is right next door to such a sweet-sounding place. Chloe Johnston was working behind the counter at Le Petit Sweet when I entered the store and described what they were offering that day. I was overwhelmed with the variety: orange blossom doughnut, cranberry orange scones, churro doughnut, blueberry doughnut, chocolate chip cheesecake, cheesecake with raspberry drizzle, lavender honey cookie, French vanilla macaroon, pistachio-Craisin biscotti, white chocolate biscotti and much more.

A former wedding cake designer, owner Brittany Baker was in the kitchen working her craft as her father, Ron Baker, described his daughter's passion for baking. Brittany was born in Miami and opened a custom cake shop. She moved to Mount Dora a few years ago when she was attracted by the small-town charm. She still makes wedding cakes but also helps out her neighbors by decorating the doughnuts brought over each day from the doughnut shop down the street. This boutique-style bakery is big on taste and made it hard not to walk out of there with one of everything.

While walking back to our hotel room with my bag of bakery sweets to share with Jack, I decided to stop by the Gate House gift shop at the historic Lakeside Inn. Inside, I met Susan M. Grogan, an artist whose work is for sale in the shop, along with other artists. We talked about the charm of Mount Dora and what an asset it is to have a shop like Le Petit Sweet around.

In the Tampa Bay area, we have a large selection of shops selling doughnuts, but when my sweet tooth starts calling me, I run to Dough. They also have doughnut ice cream cones filled with soft-serve, cupcakes, cheesecake, cookies and more. Dough is located next door to the award-winning Datz restaurant, which is described as a place that serves "comfort food with flair," and "Dough is the candy-coated sister." My selection of doughnuts for the day were colorful, different and all delicious: maple bacon éclair, crème brûlée, brown sugar with Bavarian cream, fritter doughnut, cinnamon roll doughnut, birthday

Florida, the Sunshine State, 1960.

cake doughnut, pink lemonade doughnut, s'mores doughnut, red velvet and French toast doughnut. If a doughnut shop can have a sense of humor and great confectioners, Dough has both.

Florida is a land filled with tropical treats made from exotic fruits. From south of Miami to north of the Florida Keys is an area known as Redland Tropical Trail. With its subtropical weather and rich soil, flavorful fruits flourish in the area. To get an up-close look at and learn more about the variety found, you could take a trip to the Fruit and Spice Park or visit the roadside attraction/fruit stand known as Robert-Is-Here. In 1959, the stand was selling only produce along the side of the road, but Robert-Is-Here now offers much more with jelly and preserves, shakes and pies and an animal farm out back. Nearby, Knaus Berry Farm, an open-air market, seems to be more noted for the sticky buns they sell out of early than the berries. What started as a small roadside stand selling strawberries in 1956 now offers a variety of baked goods, including their locally famous sticky buns, along with honey and jelly, tropical shakes and ice cream. Knaus Berry Farm and Robert-Is-Here are both open seasonally, so be sure and check their business hours before visiting.

The Florida Tropical Cook Book, published in 1912, includes instructions on how to prepare tropical fruits in a variety of ways, from salads to ice cream and other desserts. Written as a guide for those new to the area, many of whom had never seen a lot of what was growing and thriving in the hot and humid subtropical atmosphere, over half the recipes in the book are for something sweet and most, but not all, for something tropical. Some of the unusual recipes are for sweet flag, cecropia, otaheite gooseberry and tropical gooseberry, Jamaica sorrel, Surinam cherry, roselle, paw paw and scuppernongs. It includes a recipe for guava jelly from the annual report of the 1908 Florida Experiential Station, Press Bulletin No. 118.

Guavas are a popular filling for pastries, popovers and jelly making. Alessi Bakery in Tampa and Café Versailles in the Miami airport make delicate and delicious guava pastries. Marjorie Kinnan Rawlings recommended "the canned Cuban guava found in the Cuban quarter of Tampa, served with cream or eaten with cream cheese and crackers" for dessert.

From Punta Gorda to Palm Springs, pineapple cultivation was growing strong in the mid-1800s, but by the early 1900s, it was on the decline. Pineapples are now often associated with Hawaii, but they were first cultivated in Florida. From the Keys to West Palm Beach and as far north as Orange County, pineapple fields flourished. Disease, competition from Cuba and freezes brought the industry to a halt. But the flavor still lingers on

our taste buds and might explain the popularity of a soft-serve swirl created by Dole and served at Walt Disney World. People come from all over for a tropical taste, including Michael Kiser and his son Mingus visiting from Portland, Oregon. Grandparents Deb Kiser and Jim Kiser from Hilton Head, South Carolina, and friends Melissa Russell and Isidore Stockman waited patiently as Michael and Mingus stood in line for their pineapple treat.

Plantains, a hybrid banana, are another tropical treasure, and Jack and I had the pleasure of watching waiter Zack Endrias of Pisces Rising in Mount Dora flambé a dish of plantains for Karen Romeo of Tavares for her dessert selection of Plantain Foster. This Florida flambé dish uses sweet sautéed plantains, brown sugar, butter, condensed milk, vanilla, tequila, ice cream and cinnamon.

Mangos are a popular fruit eaten a variety of ways, with over one hundred varieties, but the Hayden mango stands out as a turning point in the development of mangos in Florida. In the early 1900s, when Captain A.J. Hayden retired from the U.S. Army, he and his wife, Florence, moved to South Florida. They enjoyed cultivating fruits and flowers and experimenting to create superior and better-tasting varieties, especially the mango. Just before Captain Hayden passed away, they developed a new variety of mango. His wife continued with the research and development before sending specimens to the United States Department of Agriculture (USDA). Her request was to have this new variety named "for the man who produced it." Working for the USDA, botanist Dr. David Fairchild, in charge of Foreign Seed and Plant Introduction, declared, "It is the most delicious fruit in the world." The Hayden improvement included a smooth and glossy skin with the texture between that of an apple and a peach. Later, other mangos surpassed the Hayden, but Rawlings describes the "Haden" mango, developed in Coconut Grove, as having a texture "like cream melting on the tongue" and so juicy it should be eaten with the sleeves rolled up over the kitchen sink.

Following is a recipe for chutney by Mrs. Florence P. Hayden from *The Florida Tropical Cook Book*:

Chutney No. I

Ten large fine mangoes, one-half pint seeded raisins, one-half pint lime juice, one-half pint vinegar, two chili peppers, two garlic buttons grated, one medium-sized onion, one tablespoonful white mustard seed, one tablespoonful ground ginger, one heaping tablespoon of salt, one and one-half pounds brown sugar. Pare and cut mangoes in small pieces. Put all ingredients in a crock or

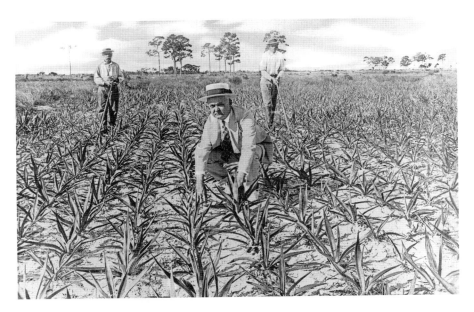

Postcard from the 1920s featuring a pineapple field.

bowl. Let it stand covered overnight, and cook it very slowly next morning for three hours. Put in glass jars or bottles, and seal at once.

As you savor the sweetness of our culinary heritage, you will find a variety of multicultural sweets within ethnic enclaves that began as immigrants moved to America to follow their dreams of a better way of life. Reading about the history of these areas highlights some of the sweets they brought to this country to continue the traditions of their homelands, making America an even better place to live and work and eat. The Minorcans of New Smyrna are known for the coconut candy they make at Christmastime. You will find one of the largest enclaves of Greeks in Tarpon Springs and a melding of cultures with the baklava of their homeland, now laced with Florida honey and southern pecans. The German Yalaha Bakery, located along an isolated stretch of County Road 48, just west of Howey-in-the-Hills and east of Okahumpka, opened its doors in 1995. People trek across the state for a taste of German sweetness provided by the owner, Juergen Clumb. With the help of Sandy Pasch, Julia Rodriquez and Santina Kingsley, Jack and I made our selection: the Bee Sting Yeast Cake made with Bavarian cream, honey and toasted almonds, the most popular pastry, and the Very Berry Bavarian Torte, which comes in second.

One dessert that is becoming as common as Key lime pie is Spanish flan. How can a tiny little upside-down dessert garner so much attention? One taste and you will see why. Jack and I had Cuban flan and coconut flan at Little Havana's Cuban Bar and Cocina, along Calle Ocho in Miami. Ybor City has hosted a flan festival for home cooks and professional chefs, and there was pineapple flan, chocolate flan, orange flan, strawberry flan, honey flan and much more. While growing up, Joe Lopez learned how to make his creamy, dense, caramel-covered flan at his mother's side. He now sells his commercially.

When Jack and I were married, my friend Lisa Tamargo gave me a copy of *Clarita's Cocina: Great Traditional Recipes from a Spanish Kitchen*, by Clarita Garcia. It's a local cookbook with a wonderful collection of Spanish recipes, including the recipe "*Flan de Leche Acaramelado* (Spanish Caramel Custard)." A few simple ingredients of milk, eggs, sugar and vanilla are combined to create what Garcia describes as the one that takes top billing in Spanish desserts.

Lisa's mother, Elisa Morales, doesn't use a recipe when she makes her flan for special occasions, but somehow it always turns out just right. She learned how to make it by watching her Spanish mother-in-law, Violet, cook. Lisa's cousins Marlina Johnson and Lorna Cacciatoer shared their recipes for Violet's flan as well, each one a little different. One points out that you can use a 1½-quart dish or six oven-proof custard cups; the other has a shortcut for caramelizing the sugar that she feels Violet would approve of by mixing the sugar and water in a small skillet and cooking until golden.

Elisa's Florida Flan

sugar and water
4–6 eggs, well beaten
I can sweetened condensed milk
I can water in the condensed milk can, stirred to remove remaining milk in can
I can whole milk
½ teaspoon vanilla extract

Gradually pour sugar in 2½-quart Corningware dish with water and cook over medium heat, stirring and shaking until it hardens.
Whisk remaining ingredients together.
Pour into dish with melted sugar and place in a 2-inch pan of water.
Bake at 325 or 350 degrees.

Do not let water boil, adding tap water to the pan to stop the boiling as needed.

Cook approximately 1 hour.

To determine when it is done, test periodically with a knife. It is done when the knife comes out clean.

It comes so naturally to Mrs. Morales that she assumes, "Oh, everyone knows how to do that" when describing how to prepare the pan with a melted sugar coating. But everyone doesn't know how, and it takes the talent of her gifted hands to create a flan of which dreams are made.

PS from Pat

Prior to my graduation from Humpty Dumpty Kindergarten and moving on to first grade at Parker Elementary School, midday dessert treats were memorable ones because I got to try new and exciting sweets. The morning snack of two Ritz crackers and a Dixie cup of Kool-Aid were provided by Mrs. Tucker and Mrs. Bean. The "sweet treats of the day" were passed out in the afternoon by Mrs. Tucker—mostly store-bought cookies such as Quik-Chek brand (now Winn-Dixie) chocolate chip and lemon cookies. Prior to each meal, we had to say the blessing. After the food was passed out and before we could start to eat, we all prayed the same prayer each day: "God is great, God is good (I thought it was Goddess great, Goddess good), let us thank him for our food, by his hands we are fed, thank you Lord for this daily bread…Amen." One afternoon, I was sitting across the table from Billy. That day, our treat was chocolate-covered coconut-filled cookies. After the prayer, Billy stuck the entire cookie in his mouth and started eating. A few bites into his chewing, I reckon Billy realized he didn't like coconut. He spit out the cookie in a slow and dripping manner that a kindergarten-aged boy can do best. Because of this vivid memory, it was not until twenty-seven years later, in 1987, that I could finally eat coconut again. Funny how a starvation course called U.S. Army Ranger School will change the way you feel about foods that you thought you didn't like to eat.

Bibliography

Barbour, George M. *Florida for Tourists, Invalids, and Settlers.* A facsimile reproduction of the 1882 edition.

Bartram, William. *Travels and Other Writings.* 1791. Reprint, New York: Penguin Books, 1996.

Bass, Bob. *When Steamboats Reigned in Florida.* Gainesville: University Press of Florida, 2008.

Claiborne, Craig. *Craig Claiborne's Southern Cooking.* Athens: University of Georgia Press, 2007.

Crosby, Alfred W., Jr. *The Columbian Exchange.* Westport, CT: Greenwood Press, 1973.

Davies, Frederick S., and Larry K. Jackson. *Citrus Growing in Florida.* Gainesville: University Press of Florida, 2009.

Dickinson, Jonathan. *Jonathan Dickinson's Journal.* Edited by E.W. Andrews and C.M. Andrews. Port Salerno: Florida Classic Library, 1985.

Egerton, John. *Southern Food: At Home, on the Road, in History.* Chapel Hill: University of North Carolina Press, 1993.

Hines, Duncan. *Adventures in Good Eating.* 5th ed. Chicago: Adventures in Good Eating, 1938.

Kennedy, Nancy. *The Ford Treasury of Favorite Recipes from Famous Eating Places.* New York: Simon and Schuster, 1955.

———. *The Second Ford Treasury of Favorite Recipes from Famous Eating Places.* New York: Simon and Schuster, 1954.

Laxer, David, and Christina Laxer. *Bern's Rare and Well Done*. Winter Park, FL: Story Farm, 2015.

McCarthy, Kevin. *Christmas in Florida*. Sarasota, FL: Pineapple Press, 2000.

McPhee, John. *Oranges*. New York: Farrar, Straus and Giroux, 1967.

Rawlings, Marjorie Kinnan. *Cross Creek*. New York: Touchtone, 1996.

Romans, Bernard. *A Concise Natural History of East and West Florida*. A facsimile reproduction of the 1775 edition.

Stage, Sarah, and Virginia B. Vincenti, eds. *Rethinking Home Economics: Women and the History of a Profession*. Ithaca, NY: Cornell University Press, 1997.

Stowe, Harriet Beecher. *Palmetto Leaves*. 1873. Reprint, Gainesville: University Press of Florida, 1999.

Tannahill, Reay. *Food in History*. New York: Three Rivers Press, 1988.

Toussaint-Samat, Maguelonne. *A History of Food*. Paris: Wiley-Blackwell, 2009.

Trager, James. *The Food Chronology*. New York: Henry Holt and Company, 1995.

Visser, Margaret. *The Rituals of Dinner*. New York: Penguin, 1992.

Weaver, Brian, and Richard Weaver. *The Citrus Industry in the Sunshine State*. Charleston, SC: Arcadia Publishing, 1999.

COOKBOOKS

Berolzheimer, Ruth. *The American Woman's Cookbook, New and Revised*. Chicago: Culinary Arts Institute, 1953.

Camellia Garden Circle. *Camellia Cookery: Tallahassee's Favorite Recipes*. Tallahassee, FL: Camellia Garden Circle, 1950.

Carlton, Lowis. *Famous Florida Recipes: 300 Years of Good Eating*. St. Petersburg, FL: Great Outdoors, 1972.

Carter, Susannah. *The Frugal Housewife, or, Complete Woman Cook*. A facsimile of the 1792 edition.

Child, Lydia Maria. *The American Frugal Housewife: Dedicated to Those Who Are Not Ashamed of Economy*. A facsimile of the 1832 edition.

Dull, S.R. *Southern Cooking, 1941*. New York: Grosset & Dunlap, 1968 edition.

Farmer, Fannie Merritt. *The Boston Cooking-School Cook Book*. 8th ed. New York: Little Brown, 1948.

First Presbyterian Church Miami. *The Florida Tropical Cookbook*. A facsimile reproduction of the 1912 edition.

Fisher, Abby. *What Mrs. Fisher Knows About Old Southern Cooking*. 1881. Reprint, Carlisle, MA: Applewood Books, 1995.

Garcia, Clarita. *Clarita's Cocina: Great Traditional Recipes from a Spanish Kitchen*. Garden City, NY: Doubleday Company, Inc., 1970.

Glasse, Hannah. *The Art of Cookery Made Plain and Easy*. A facsimile of the 1805 edition.

Gordon, Jean. *Orange Recipes*. Woodstock, VT: Red Rose Publications, 1962.

Harris, Jack, and Joy Harris. *Easy Breezy Florida Cooking*. Gainesville: University Press of Florida, 2010.

Hess, Karen, ed. *Martha Washington's Booke of Cookery and Booke of Sweetmeats*. New York: Columbia University Press, 1981.

Junior League of Tampa. *The Gasparilla Cookbook*. Tampa, FL: Favorite Recipes, 1961.

London, John L., and Geneva L. Jurkewicz. *The Florida Keys Gourmet's Guide*. Key West, FL: Island Graphics, 1976.

McCulloch-Williams, Martha. *Dishes and Beverages of the Old South*. A facsimile of the 1913 edition.

Mrs. Hill's New Cook Book: Housekeeping Made Easy—A Practical System for Private Families, in Town and Country. A facsimile of the 1875 edition. N.p.: Antique American Cookbooks, Oxmoore House, Inc., 1985.

Nickerson, Jane. *Jane Nickerson's Florida Cookbook*. Gainesville: University Press of Florida, 1984.

Randolph, Mary. *The Virginia Housewife, or, Methodical Cook*. A facsimile of the 1860 edition.

Rawlings, Marjorie Kinnan. *Cross Creek Cookery*. New York: Fireside, 1996.

Simmons, Amelia. *American Cookery*. Mineola, NY: Dover Publications, 1984. A facsimile of the 1796 edition.

Wilcox, Estelle Woods. *The Dixie Cook-Book*. A facsimile of the 1883 edition.

Woman's Club of Key West. *Key West Cook Book*. New York: Farrar, Straus and Company, 1949.

ADDITIONAL SOURCES

Davies, Kristy. "Emerald Coast's Cake Boss: Jason Hendrix Learns Life, Like Sweets, Should Be Savored." *Emerald Coast Magazine*, June–July 2012.

Green, Clarissa. "Two Delightful Florida Fruits: The Mango and Papaya." *Suniland Magazine*, November 1925.

Henry B. Plant Museum. *Moments in Time.*

Izon, Juliet. "The Queen of Cuban Ice Cream." *Ocean Drive Magazine*, February 4, 2014.

Maddox, Lynn. "Candy Factories Sell a Bite of Florida." *Lakeland Ledger*, June 28, 1972.

Milton, Elizabeth. "How Sweet It Is!" *Daytona Beach News Journal*, August 6, 1978.

Olien, William C., and C. Patrick Hegwood. "Muscadine: A Classic Southeastern Fruit." *Hortsicence* 25, Clemson University Department of Horticulture (July 1990).

O'Neil, Shannon. "Front Door Feature: A Literary Legacy in the Dunes, Marjorie Kinnan Rawlings' St. Augustine Beach House." *First Coast Magazine*, 2016.

Sarasota Herald Tribune. "Florida Strawberries Have History." March 5, 1964.

Strauss, Mark. "5000-Year Secret History of Watermelon." *National Geographic Magazine*, August 21, 2015.

Index

INDEX

About the Author

Joy Sheffield Harris was born in Tripoli, Libya, on Wheelus Field Air Base and then moved to Florida just in time to attend Humpty Dumpty Kindergarten and later Florida State University. She went on to become a home economics and history teacher at her alma mater, Rutherford High School, in Panama City and a marketing specialist for the State of Florida. Joy met her husband, Jack, while promoting Florida's natural bounty on television in the early '80s. After they were married, they briefly owned a restaurant with friends called Harris and Company, and in 2010, they co-wrote *Easy Breezy Florida Cooking*. Their son, Jackson, works in the aviation industry, and when he comes to visit, they all enjoy traveling throughout the state of Florida. In 2014, Joy wrote *A Culinary History of Florida* and continues her studies of Florida food with *Florida Sweets*.

Visit us at
www.historypress.net
..
This title is also available as an e-book